Photography

The Ultimate Beginner's Guide!

Contents

Introduction

Today, you will learn about photography. It will be assumed that you are currently using a digital SLR or DSLR. However, take note that learning photography using this book will be much better if you are using a DSLR. Nonetheless, it does not mean that you cannot use a compact digital camera or a smartphone camera in learning photography.

Take note that DSLRs, if you are a new owner, can be very daunting at first. Unless you have prior experience in use using SLR cameras (the ones using film and have a dial on top), learning how to use a digital camera can be a bit challenging for you.

This book will teach you how to handle your DSLR first. But mostly, it will be focused on how you can and must control the light in your photo using your camera. Do note that in photography, lighting is everything.

Even if you master the functions of your camera, getting a high quality photo will be difficult if you cannot even understand the importance of manipulating and taking advantage of the light sources around the scene you want to take. Although, if you have a "good eye" for aesthetics, you can.

But the question is, do you have that "good eye"?

It will be assumed that you do not have one. However, if you do and you just want to learn using your camera, this book can still be a useful guide for you.

Anyway, enough chitchat, and get a move on the first chapter.

Chapter 1: Your Camera

There are four important factors in photography: your camera, your subject, the light sources, and of course, you, the photographer. You are reading this book to improve yourself. And the first step in doing that is to know your camera.

Viewfinder

A modern camera has six basic parts. First, it has the viewfinder. In old SLR cameras, the viewfinder is that small glass panel that you peek into when "targeting" the subject that you want to capture on film.

In modern digital SLRs, the ones called DSLRs, two viewfinders can be found. DSLRs still usually have the typical glass panel viewfinder. In addition to that, they have the LCD screen viewfinder. Not all have the LCD screen, by the way.

The viewfinder is where you view your subject, and determine the composition of the photo that you want to take. It is usual that viewfinders have these lines, circles, and/or rectangles on them. You can use those "guidelines" to measure and level the composition you are making.

By the way, different types of cameras often have different mechanisms on how they provide the "image" appearing on the viewfinder. In DSLRs and SLRs, the image that you will see there is the image that goes through the camera's lens itself.

Despite not being "directly connected and adjacent" to the lens, DSLR and SLR viewfinders provide an accurate representation of the image that will go through the lens and will register on the camera.

This is made possible by a mirror that reflects the image or light, which goes through the lens, and redirects it to the

viewfinder. Some pocket cameras and digital cameras' viewfinders do not work like this. Most of the time, the image on the viewfinder and the shot will have a minor offset difference.

On the other hand, in smartphone cameras, the only viewfinder that you can use is the display of the phone itself only.

Do note that, technically, the viewfinder in the glass panel is called an optic viewfinder. Alternatively, the panel (usually LCD) that acts as a viewfinder and menu display is referred to as a hybrid viewfinder.

Another type of viewfinder, which is uncommon in consumer DSLRs, is the electronic viewfinder (EVF). It is often found in some cameras, but can be mostly seen in video cameras. They are miniature LCD displays, often shaped as a tube, which act as a viewfinder.

Shutter Button
This button acts as a trigger for you to command your camera to shoot. More often than not, shutter buttons provide a function when you half-press it. Usually, it will start certain features like initiating light and exposure functions.

Sensor
The sensor is a small device in the core of your camera. It is behind the lens, and it is the one responsible for capturing an image. It records the light that goes through the lens, and writes it as digital information or file.

Mode Dial
A DSLR (and a few point and shoot digital cameras) often comes with a mode dial. With the dial, you can easily switch the shooting mode that your camera will follow. It usually includes the following functions:

- Auto — labeled as Auto
- Program — labeled as P

- Shutter — labeled as S or TV (depends on camera brand)
- Aperture — labeled as A or Av (depends on camera brand)
- Manual — labeled as M
- Sports — labeled as swimmer or runner icon
- Landscape — labeled as mountain icon
- Portrait — labeled as a face
- Macro — labeled as flower icon

The first five on the list are camera modes. In each mode, you will be allowed to have manual, semi, and auto control of the camera's settings, which are aperture, ISO, and shutter speed. Those settings will be explained later.

The four remaining options are called scene modes. They are predefined setups that can allow you to shoot the scene that you want without worrying about your camera's setup. Some other modes or predefined sets can be present or not on the mode dial.

In some modern cameras, there are almost around 15 or more modes and scene modes combined, which are often accessible on the camera's menu.

Also, do note that manufacturers or camera brands do have these icons and label mixed up differently. It will be best for you to consult your user manual to get a better idea on what modes are available in your camera and what the labels and icons mean.

LCD Display (Live View Panel) / Mini LCD Display or Control Panel

Your camera will have one of these two. Before LCD displays on DSLRs proliferated, most DSLRs back then were equipped with a mini LCD display near the shutter button, which people often refer to as the control panel.

The main differences between the two are the size, display type (monochrome or full color), and the live preview function.

Chapter 2: Lens

The next part is the lens. And since this part is being introduced to you, and your interest most probably gravitate towards this part of your camera in the future, some tips and pointers about the types of lenses you might want to get or use will be provided here.

The primary function of the lens is to give your camera the "range" it needs. This range is what you call focal range or length. Technically, the focal length is the distance between your camera's sensor and the lens itself. The focal length is measured in millimeters, and lens focal length often comes in 35mm and 50mm.

The distance of the lens from the sensor can affect the resulting photo in your shots. More often than not, the type of lens and focal length of the lens determine and even limit the photography style that you can do with your camera.

And due to the power of lenses to dictate that aspect of your photography, they are often priced highly. Most of the time, lenses are more expensive than the camera body itself. So, it is often advised by veterans that it will be much better for you to invest in the best lens you can have than the camera itself.

Focal Length
The focal length of your lens can change a variety of aspects in your photography. First, the angle of view of your camera changes depending on your lens' focal length. The angle of view is the amount of area that your camera can capture.

The shorter the focal length of your lens, the wider your angle of view becomes — the greater area your camera can "see" and capture. Due to that, short focal length lenses are often ideal for landscape photography.

On the contrary, the longer the focal length of your lens, the narrower your angle of view becomes — the lesser area your camera can "see" and capture. Due to that, longer focal length lenses are often ideal for portrait photography.

Focal length also affects the zoom of your camera. Imagine that your subject is 10 meters away from you. Using a 12mm to shoot that subject, the subject will appear small in the photo. On the other hand, if you are using a 135mm, your subject will appear bigger and closer.

Prime and Zoom Lens
Common camera lenses can be roughly categorized into two types: Prime and Zoom. Take note that some people think that a prime lens means your first lens or primary lens that you use — that can be quite confusing.

Put into mind that a prime lens is a fixed focal length lens. Basically, a prime does not have a zoom function. On the other hand, zoom lens has a variable focal length adjustment, which you can just informally refer to as zoom function.

There are other types or subcategories of lenses such as telephoto and macro — and then there are wide-angle, ultra wide, and fisheye — but they will not be discussed here fully.

Choosing Your Lens
By the way, another function that the lens serve is protection against dust, dirt, and other small elements that can get inside your camera.

If you have just bought your camera and just bought it straight from the shelf, you will probably have a regular lens. Do not worry about the specs of the lens at this point. You do not need to worry if you need a telly (telephoto lens) or wide range zoom lens. Usually, you will be provided with one of four different lenses: 85mm, 50mm, 35mm, or a regular zoom lens that has a range from 16mm up to 80mm.

However, if you have not bought a camera yet or you have just bought a camera body, be prepared; choosing your first lens can be a life-changing and difficult decision. Okay, that may be a slight exaggeration — but if you are strapped for money and you do not have a lot in your coffers, then yes, buying your first lens is a major thing.

Prime and Zoom Lens

You should think about it very hard. But here is a rough guide to help you choose. It will cover some basics tips about getting a first prime lens and a bit about zoom lens.

Primarily, if budget is your concern, you will definitely have to choose between 35mm and 50mm. These two lenses are ideal and practical for beginner photographers. They have a wide range of uses, but of course, they have their own advantages and disadvantages

Also, they are cheaper because they are commonly used. In addition, they are in the middle of the usual focal range. Both can be used for landscape and portraits.

- 35mm: If you aspire to be a street photographer, photojournalist, or portrait or landscape photographer, the 35mm is a good choice. Of course, the 35mm is not limited to those alone. You can use it in almost any chances you need to take photographs, and in any location, too.

 It is also capable of giving you enough wideness in the photo even if you are taking a photo of a subject that is a meter or two away. Most travelers choose the 35mm. Not only is it versatile, but it is also comparatively lighter than the other lenses.

 And you might have heard about this, but it is difficult to get "bokeh" pictures in 35mm. "Bokeh" is a photographer term for the blurriness, often intended by

the photographer, of the background (or foreground) in a picture that is aesthetically pleasing to the eye.

If you have poor eyesight, try to walk around at night and look at a lamppost from far away. You will see that the light of the post gets blurry and it becomes a ball of light. In daylight photography, bokeh is the nice blur on the background or foreground that creates a nice separation of your subject matter and the blurred-out-of-focus part(s).

- 50mm: The 50mm is also a versatile lens that you can use in everyday photography. However, do note that because of its length, it will have some minor differences. To be precise, its additional length can change how your photo appears.

 First, you can easily get an out-of-focus shot. The background of your subject matter will be blurred a bit softly. You will not have everything crisp and sharp in your photo, unless there is no subject that is far away from your main. Aside from that, to prevent getting out of focus when taking photos around you, you should step back a bit.

 That could be a disadvantage if you are taking a photo in a place with not enough room. In addition, it is particularly heavier than the 35mm. Well, not that much to be honest. Some are lightweight. But cheaper models are heavy. Some are a bit longer than the usual 50mm.

 Anyway, the best thing about this is that you can achieve bokeh much more easily. Aside from that, photos taken with a 50mm can be more dramatic — more artistic, if you may.

Due to the softening of a bit of out-of-focus parts, your subject easily stands out and the blurring of the background appears more vibrant and creates more contrast. However, some photographers are starting to back away from this kind of photography because it has become more common and quite cliché.

What about 85mm? Or the 16mm to 80mm zoom lens? Well, of course, compared to the two lenses mentioned above, the 85mm and the zoom lens are quite more expensive. If you are persistent about photography and you have decided to try and earn from it (or you just have money to spend or just love photography that much), that is the time when you would want to consider taking any one of these two over the previous two.

Of course, there are still advantages and disadvantages.

- 85mm: If you totally want to focus on taking portrait photos and achieve an ideal setup for it, then 85mm is the way to go. The price leap between 85mm and 50mm is huge (fortunately, 35mm and 50mm have a decently short gap between their prices). This is a much better choice than getting a much more expensive 85mm and above lens or a telly.

 Primarily, the 85mm will provide you with better contrast between your subject and its background. It will produce bokeh too much, which makes it easier to achieve. Due to that, it also creates a nice subject isolation.

 Another thing is that its focal length is ideal for photo studios. You do not need to get close to your subject to get a headshot, and you will be meters away when taking a shot.

9

Aside from the price, a disadvantage that you should know is its weight. With an 85mm, you can definitely feel the heaviness of your camera. Despite having a focal length, it is still good to use for street photography. It can easily produce fancy pictures with your camera. But again, the only deal breaker people see with the 85mm in street photography is its weight.

- Regular zoom lens: First of all, you will have all the lenses mentioned before in one package. You can go for a landscape photo or a decent portrait photo by just turning your zoom dial or ring. Also, if you want to close the distance between you and your subject, you do not need to move anymore.

Just adjust your zoom, and you will get the ideal focal length instantly. This is a complete advantage when you are using a tripod and you have limited movement space. In addition, if you are planning to use a filter, you will not need to switch between lenses and filters anymore with a zoom lens. Just leave your filter intact in the zoom, and you are good to go.

And for a candid reason, a zoom lens can allow you to shoot pictures of people from afar — stealthily — just like a paparazzi photographer. You will be in a safe distance when the person you took a photograph of spots you and gets upset. You can run away fast. (Just kidding — but it is true and applicable in real life.)

Of course, it is not just for getting paparazzi photos. It is an excellent substitute if you are into wildlife photography. You can easily shift from macro photography or take photos with a decent range with a zoom lens.

By the way, macro photography is very close range photography. When you take pictures of ants or

anything within a meter, than can be considered macro. There are macro lenses built for macro photography, but you can still do it with your regular lens. Some do it raw by just trying to achieve macro by simply getting closer. Some people do it by reversing their lens, but it will not be touched upon here further since it can be risky for your lens and camera's health.

Aside from that, if you are going to suddenly shift to taking videos, a zoom lens is a must for you. With variable focal length, you can easily shift in and shift out your focus when shooting a video of a moving object without the need to get into a set proximity to avoid getting your subject out of focus.

How about lens in smartphones and digital camera? Most digital cameras come with a built-in zoom lens. Of course, unlike DSLRs with detachable lens, the lenses in digital cameras are limited and unchangeable. So, you will be stuck with your camera's range, and will not be able to achieve certain photography techniques with it.

On the other hand, smartphone cameras commonly do not have lens in them. However, you can get smartphone lens accessories for your phone. Unfortunately, the lenses do not fit all phone cameras. Most of them are built for popular phones like iPhones.

Nevertheless, some manufacturers provide their lenses with phone casings and some mechanisms to let you use them on any kind of smartphone. If you do not have any lens for your phone, then you will be stuck with the traditional digital zoom. Some offer minor optical or mechanical zoom, but they are much weaker than the usual digital camera lens zoom.

Chapter 3: Photography Basics — Light and Exposure

By now, you should be familiar with your camera. At this point, you will learn how to deal with light sources. Of course, this chapter will still talk a lot more about your camera's functionalities.

Exposure

Before you go into the other technicalities in photography, you should familiarize yourself with exposure. Usually, most new photographers ignore this part, and some aspiring photographers will put exposure as the last thing that they need to learn or think about.

What is exposure anyway? Is it that important? In the good old days, exposure means getting your film exposed to light. For those who are familiar with cameras — film cameras for that matter — they will often refer to exposure as an accident when a film has suddenly been exposed to light, and not through the camera's lens.

The layman has often used that term and associated it with the mistake of opening a camera while the film is still spread and not yet rolled.

However, exposure is not "always" an accident. Exposure is how pictures get "printed" on the film. Even if you talk about a film or digital camera, the process of exposure is the heart of photography.

In films, film is exposed to light to create a negative. Films are coated with chemicals that will react when exposed to light. On the other hand, digital cameras use sensors. These sensors act like films. Sensors have tiny receptacles that, when exposed to light and the shutter button is pressed, record rays of light that hit them as data.

Since you are going to be a photographer, please take note of this concept since photography will revolve around this process. As you might have noticed, exposure is a simple idea to understand. However, having full control of it is a different story.

Over and Under Exposure
In taking pictures, there are two things that you must avoid. First is by getting an over-exposed photo. Second is getting an under-exposed photo.

An over-exposed photo is a photo that has absorbed or recorded a lot of light — to the extent that the colors that should be in the photo are totally washed out by the light.

On the other hand, an under-exposed photo is a photo that has received or recorded too little light to the point that the colors in the photo are too dark for you to discern what they are.

However, it does not mean that both under- and over-exposed photos are bad. For example, you might want a picture of a person and let his silhouette show in the photo only. Because of that, you will need to get the photo under-exposed to achieve a silhouette even if your background or the scene you are in is bright.

On the other hand, you will need to over-expose your photo in case that you are shooting in the dark or in an area with little natural light in order to get that crisp and brighter image.

Over-exposing your photo will make your camera, or its sensor, to take in more light. This allows the camera to produce an image with a decent amount of light or color information even if your light source is weak or dim.

But in regular or point-and-shoot photos, they must be avoided. If you are just taking a picture, too much or less light can be bad for your photo, because having little or too much light in your photos can take away some important details like color information.

For example, if you shoot a photo of the sky and it is too sunny, your photo will be washed out because of the intensity of the light coming from the sun. Because of that, the information that you want to get into your photo like the blue sky or the clouds will not register in the photo because light has provided too much "white" on the photo — to the point that the sensor was too blinded to "see" the blue in the sky and the shade of the clouds.

Are you still not convinced or are you having a hard time understanding the explanation? Try this: Look directly at a light source — not the sun of course. A light bulb with a high wattage is a good source.

Just like the camera, the intense light of a bulb can prevent you from seeing anything else. The same goes for other light sources such as a headlight of a car set to high beam.

The reverse happens when under-exposing a photo. The weaker the light source you have, the darker the photo and less color information will be registered in it. A quick example for this scenario is a dim bedside lamp.

As mentioned before, light plays an important factor when you are taking a photo. It is a must that you make sure that the light levels within your area or scene where you are shooting from and where the subject is has ample amounts of light for you to avoid under-exposure or over-exposure.

Light Meter

One way to determine if the light in your location is suitable for a good shot is to use your camera's light meter. Separate light meters can be bought, but for now, settle with your camera's light meter function. It is more than enough for various applications.

Another method you can use is to use your eyes. It sounds silly, but more often than not, it can be more reliable to train your eyes as early as now to measure light. Also, you do not need a camera to determine the light source anyway.

Of course, the light meter in your camera does not only check lights. It also provides your camera information on how it should shoot. Before anything else, do note that cameras nowadays are set to auto mode.

When in auto mode, the camera will depend on various features and functions to determine the right settings for the shot you will take. So, for now, understand that you will need to set your camera to auto for you to try the following steps, examples, and tips that will be mentioned in this section of the book.

Anyway, you can check your viewfinder or your camera's display to check if the light you are getting is too much or too less. On the other hand, you can just take a photo and check if the photo will be over-exposed or under-exposed.

This has been the viable and most used option nowadays since every shot you take does not waste any film, which was, until today, expensive. Since you are not using film anymore, all that is wasted in your test shot is a few seconds of pushing buttons and seconds of battery life.

By the way, as a pro tip, do your deleting at home and in a computer. Why? First, deleting on location can be a waste of time — not to mention tedious. Browsing your photos and deleting multiple files in your DSLR is a tad difficult and time-consuming. Also, preventing yourself from pressing your menu buttons in your camera too much can extend the lifespan of those buttons.

Two, you might throw away a good picture without knowing it. Three, you will not have a backup to recover a photo on the spot. And four, it allows you to carefully handpick the shots that you want to keep or dispose of when they are all laid out in front of you in a larger display like a computer monitor or television.

"But I will have no more space in my memory for the other photos that I want to take!" The solution for that is easy. Bring

another memory card with you. An extra one is not that expensive, and it is very handy to have. Most professionals carry two or three extra memory cards with them.

In addition, keeping your test shots is a good way to have references. It can let you learn and remember the things you did during the shoot to achieve a photo that you wanted to get.

Lighting

If you have already tried to take some advice from seasoned photographers, you will often hear them say, "In photography, lighting is everything."

That is a fact. And it can never be emphasized enough. By being oblivious about the light settings of your camera and scene, you will only waste time and frustrate yourself.

Aside from the aforementioned steps to "control" light, you can still perform other methods. One of those methods, and generally preferred by many, is to tweak your camera's aperture settings, which will be discussed in the next chapter.

Chapter 4: Introduction to the Golden Triad — Aperture, Shutter Speed, and ISO

To control the light that your camera will record as data or expose in film, you must know about manipulating your camera's golden triad. The golden triad is the three aspects of your camera that directly impacts the amount of light that gets through the lens until and after it reaches the sensor or film.

The golden triad consists of the aperture, shutter speed, and ISO. They can be tweaked by setting your camera into Manual mode. They are automatically adjusted when you choose a predefined scene setting or when you are in Auto mode.

On the other hand, if you just want to control one of them, you can go into a semi-auto mode. Semi-auto modes are Aperture priority and Shutter priority. In these semi-auto modes, you can control aperture and shutter only, respectively. The other settings will be locked or will be automatically adjusted by the camera to compensate for the exposure compensation setting you will set.

Aperture
The aperture, or aperture stop if you want to get technical, is a small hole that is situated between the sensor and lens (technically, the shutter is in between the sensor and the aperture). Its primary function is to control the amount of light that goes in to your sensor from your lens.

The aperture is commonly composed of multiple thin strips or blades of plastic or metal that form a circular hole (more of a circular or equilateral polygon depending on the make and model of the camera). It can be adjusted to create a small or huge opening for the light. Depending on the size of the hole,

the amount of light that gets to the sensor can be increased or decreased.

The aperture depends on the lens that you will get. Aside from the focal length, the range of the aperture of the lens is another consideration when getting one.

In the most basic sense, the smaller the size of the aperture, the amount of light that will reach your sensor will be lessened. And that will lead to a darker photo. On the other hand, the larger the opening or aperture, the more light will get exposed to the sensor, which will result to a brighter image.

The size or setting of the aperture also introduces other effects to your photo, which will be discussed later. For you to have a quick idea on how aperture influences your photo, form a small hole by using your thumb and index finger. Form them like a telescope.

Place that hole just in front of one of your eyes. Look through it. Stay like that for a few second. After that, make the hole a bit wider. Look through it again, and stay like that for a few seconds. Did you notice the differences when the sizes of the "aperture" changed?

Aside from the brightening of image that you can see, it also created a sense of sharpness in the image (when the hole is smaller). It also created a "vignette" effect. In addition, it created a sense of depth. Things that are far look even farther — the same goes with objects that are nearer. A bit of blur was also introduced.

When you try to look at things with different distances through the hole you made, you will be able to feel that your eye is consciously adjusting to your view. And when it does that, the object that you focus on gets clearer while the other things that are relatively distant to the object you are focusing on get blurry.

Try to shift your focus on different objects faster. When you do, you will see that there is somewhat a distortion in your image. Things get bigger while some get smaller.

However, when you widen the hole or just take away the hole entirely, you will not feel your that eye is making an effort to adjust when viewing different objects that are placed in different distances away from you. Also, the blur that happens around the object that you focus your sight on will not happen.

That is how your camera's aperture settings affect the image you take with your camera. But for now, the light controlling aspect of aperture will be discussed.

Take note that most smartphones on the market, especially the cheap and old ones, do not come with a built-in aperture. Only a few specialized and high-end phones have an aperture. However, some lens accessories do come with an aperture.

On the other hand, some point-and-shoot cameras have built-in apertures. Most of them allow adjustment. But they cannot be changed, just like with their lenses.

Anyway, to control the aperture setting of your camera, you can either go to Manual mode or aperture priority mode.

Shutter

The shutter is a mechanism that comes with a small strip of covering device to block light that will reach your camera's sensor or film. Usually, the mirror used to direct the light going through the lens to the optical viewfinder is used as the shutter.

It is situated between the sensor and the aperture. Unlike the aperture, the shutter is in your camera body and not in the lens barrel.

In film cameras, the aperture is the one that blocks the light from just coming in to the lens to prevent unwanted film exposure. And when the shutter button is pressed on a camera,

these strips of plastic open up to let light in to let the film get exposed to the light.

Generally, in modern cameras, the shutter is always open. It allows the camera to have a display on the hybrid viewfinder. However, if the camera only has an optical viewfinder, the shutter will be closed until triggered.

"Do DSLRs really need a shutter? Can they just cut off the 'writing' or 'capturing' of the image instead of creating a mechanical noise or involve wear and tear mechanical parts?"

Aside from emulating the old SLRs, the function of the shutter is to protect the sensor from dust that might creep in inside the sensor, which is especially necessary when changing lenses. It is not that effective, but it is more of an additional safety precaution.

Of course, there are multiple technical reasons behind the presence of mechanical shutters in DSLRs. But you do not need to know it now. As long as you have a basic idea, you will be good to go.

If you want to insist that you do not want that mechanical noise or the shutter itself, it will be best for you to consider mirror-less cameras. However, that is another topic of discussion — the topic alone for mirror-less cameras versus the regular ones is a favorite debate among photographers. With the recent popularity of mirror-less cameras, you might want to check it out. And do not forget to take note of the advantages and disadvantages.

Smartphones generally do not have a shutter mechanism. Despite that, these devices still are capable of having an emulated shutter. Basically, that emulated shutter is a setting that you can change to set how much time the sensor will record the data that it receives from its sensor.

On the other hand, point-and-shoot digital cameras do have shutters. But their shutters are often situated on top of the

lens. It mostly functions as a cover for the lens to avoid dust accumulation.

Photo Capture Process

At this point, you are already familiar with your camera, its main parts, aperture, and shutter. And before you go ahead and learn about the shutter speed, review how the camera captures a photo in details.

1. To start capturing a scene in your camera, you need to press the shutter button. The shutter button will activate the photo capturing process of the camera.

2. After that, the mirror inside the camera acting as your camera's shutter will go up. The light coming in that gets redirected to the viewfinder will go straight to the sensor now. Since the mirror is flipped, the viewfinder's view will be blocked. That is the reason you can see a snap on your optical viewfinder whenever you take a photo.

3. Depending on the shutter speed that you or your camera set, the mirror will stay flipped. The camera will wait until the shutter speed timer expires.

4. As this happens, the light streams from the lens, goes through the aperture, and reaches the sensor or film.

5. The sensor will start recording the data it captures. In film cameras, the chemical in the film will start reacting to the light reaching the film.

6. Once the shutter speed timer expires, the mirror will flip back to its original position. The sensor will stop getting data. On the other hand, the film's exposure to light will be stopped.

7. The camera's hardware will now process the data it recorded. Once finished, it will result into a file.

a. In film cameras, the final process is that the film will roll on to the other side of the camera. A "blank" segment will be placed at the back of the shutter. And you will be ready for another shot again.

Shutter Speed

The shutter speed controls the length of time the sensor or film will get exposed to light. The shorter the time, the fewer the light will get through. The longer the time, the more time the sensor or film gets exposed to light.

As a rule of thumb, more light results to brighter photos. Less light results to darker photos. Of course, adjusting the shutter speed also comes with side effects. Some are destructive while some are useful. But the impact of the effects truly depends upon you.

Also, do note that this is the part where cameras deviate a little from the human eye. While human eyes register images one at a time at a certain frequency, cameras combine all images it will register during the shutter speed in one image.

ISO

Another method that can allow you to control the amount of light that the sensor receives is to change your camera's ISO settings. Read a bit of history and some technicalities below before you delve into setting up your ISO setting in your digital camera.

What is ISO setting? In modern digital cameras, ISO is a setup wherein you can control the sensitivity of the sensor when it comes to capturing light. The lower the ISO setting (or number), the less sensitive the sensor is to light.

At the usual lowest ISO setting, ISO 100, the camera does not lead to darker pictures. Usually, this setting is enough to capture a well-lit scene. More often than not, the ISO setting is

used to compensate or gain more brightness in a photo in a situation where the light source provides little light.

You might be asking yourself, is that ISO related to the International Organization for Standardization? Yes. How is it connected to a sensor's sensitivity? Well, you can find the answer below.

During the days of the film camera, the "ISO setting" was not something that was built-in. Back then, you did not have any sensors. And during those days, the "ISO setting" being referred today is a measurement of a film's sensitivity to light or film speed.

Why film speed? Is that the speed of how fast the film rolls when taking a photo or video? No. That speed refers to how fast a film's chemical can react to the light that reaches the film.

The ISO and the number with it are used as a standard measurement of a film's capability to generate a negative on the film and how much light is needed to have a clear image. So, in order to change the "ISO setting" of an SLR or film camera, you will need to change films instead. Take note that when you buy a film, there will be a label that says its ISO rating.

Anyway, the ISO setting in DSLRs or other digital cameras emulates the various ISO ratings of films through various methods. Those methods are mostly technical, so it will be skipped.

Unlike the previous two settings, Aperture and Shutter Speed, ISO does not have its own priority mode. However, you can set it manually in either priority semi-auto modes or you can just let the camera decide on the ISO setting instead.

Quick Recap
All three of the golden triad can allow you to manage the amount of light that will be present in your photo. Different

combinations of their settings can lead to same levels of light. However, the side effects of changing the three of them can vary.

These effects may vary depending on the balance you create in the golden triad. And do not worry. These side effects will be covered in the next sections.

Chapter 5: The Golden Triad

With the golden triad alone, you can almost have full control of the light that goes into the camera. However, as mentioned before, as you tweak each of these settings, some favorable effects might happen.

Despite being favorable, it can be destructive if you do not have any idea what they are. Also, do note that changing all of their values is not something that most photographers recommend. To be honest, some do advise new photographers to focus on composing shots and let Auto mode decide for them instead.

Without further ado, it is time for you to go in-depth with ISO, aperture, and shutter speed settings.

ISO Setting

As mentioned before, the ISO setting of your camera adjusts your sensor's sensitivity to light. The lower the value, the more it becomes less sensitive to light. The higher the value, the more light it will allow to be mixed in the photo.

Usually, the value of the camera's ISO starts with 100. Some cameras have ISO 50 — mostly the expensive ones. Every increment to the ISO setting's value will double the sensitivity of the sensor. So, if you increment ISO 100 to the next setting, then the next ISO will be ISO 200. If you increment ISO 200, the next ISO will be ISO 400, and so forth and so on.

Shutter Speed Setting

The shutter speed is the duration on how long the shutter will stay flipped or the sensor will record light. Just like with the ISO setting, increasing the value of the shutter speed is done in increments and decrements.

Every increment will double the current value. For example, if you have a 1/125 shutter speed and you want to make it faster or increment one-stop, the next value will be 1/250.

By the way, shutter speed is measured in seconds — in fractions. For example, the shutter speed of 1/25 means that the shutter will stay flipped for 0.04 seconds.

Why do manufacturers use fractions instead of decimals in shutter speed? The shutter speed value is represented like that because fractions can be much easier for people to remember. Also, reading the fractional amount instead of the decimal amount for the shutter speed is much easier.

For example, if you convert 1/125 to decimal, you will get 0. 008 second — that is a lot of zeros and it can be confusing, especially if you add the other values that may contain more zeros.

Aperture Setting

The aperture setting is measured by using f-number. F-number stands for numerous terms. It can be referred to as focal ratio, f-stop, f-ratio, and/or relative aperture. The f-number is often denoted with a hooked f (*f*), a slash, and a number.

The f-number is the value for your aperture. And just like with ISO and shutter speed, the increments and decrements for the f-number is doubled or halved when increased or decreased.

If increased, the aperture's size will become wider. Decreasing it will make the aperture smaller. However, do note that unlike the shutter speed and ISO value, the number that is indicated in the f-number does not get doubled or halved when increased or decreased. The one that gets doubled or halved is the size of the aperture itself — relative to the previous setting or value.

Do note that the values for the f-number can be quite confusing. So, it will be best for you to memorize the values of

f-number and how it affects your photo. As a guide, take note that for normal everyday photo (for amateurs and professionals alike), the aperture setting $f/4$ is commonly used.

Extra Effects of Changing Aperture, Shutter Speed, and ISO Settings

Aside with providing you with control when it comes to adjusting the light that comes into your camera, each of the three camera settings will provide you with some extra effect, which can be favorable or destructive for you as mentioned before. Knowing what they are and when they happen will let you take advantage of these extra effects.

Aperture

For example, if you increase the value of your aperture, it will allow your camera to get more light, right? Together with that, it will also give you a shallower depth of field.

What is depth of field? Do you remember when you tried to peep into the hole you made with your fingers? When the hole was smaller, you could notice that some of your vision got blurry, especially if the objects were far away from the object you were focusing your vision on.

That is depth of field. Take note that aside from the aperture settings, the length of your lens barrel and distance of your lens from the aperture and sensor (or lens focal length) also affect the depth of field of your shots. Another few factors to take into consideration when dealing with DOF (Depth of Field) are your distance to your subject and the distance of other objects from your subject.

Do also note that with the right setup of aperture and length or "zoom" of your camera, you will be able to achieve bokeh. Bokeh is actually caused by depth of field.

Here are some important things you need to take note of:

1. The smaller your aperture is, the deeper the depth of field your shot will have. It means that the blur that is created on out-of-focus objects will become more significant.
2. The shorter your lens' focal length, the deeper the depth of field. Having a shorter focal length is like you looking through a nearsighted guy's eyes.
3. The nearer your subject is, the sharper it will look to you (with some minor consideration to the lens' focal length).

Depth of field is often favored when taking close-up photos, portraits, and macro photos. Generating DOF when taking landscapes photos from afar can be disastrous — and can be difficult.

When you are going for landscape photos, it will be best for you to set your aperture setting to f/11, f/8, or any higher value. On the other hand, if you are going to shoot still portrait pictures, it will be best for you to lower your aperture settings to f/5, f/6 or anything lower.

By setting the aperture right, you will be able to get photos that you want with the correct depth of field. For example, for landscapes that you will take with an f/4 setting, depth of field might get in the way and create some unwanted blur.

By the way, lenses have minimum and maximum f-stops. The greater range of f-stops a lens has, the more expensive it will be.

ISO

On the other hand, when it comes to increasing and decreasing the ISO setting, you will make your sensor register more or less light. However, when you increase its value, your photo will have noise. Noise? As in sound?

No. Noise in photography is different. However, the noise can be referred to mechanical noise that the shutter generates. By the way, this mechanical noise is not something you should

worry about, unless you are dreaming of becoming a paparazzi photographer.

The noise that higher values of ISO bring is the noise gradient or speckles on your photo. It greatly influences the quality of your image, and most photographers avoid this.

If you have tried to use an old cellphone camera, you will notice that there will be speckles of white, gray, red, blue, and green on your photo. Generally, people consider those photos from those old cellphone cameras as low-quality shots. Those speckles you saw are the noise. And it will appear or will become apparent in your photos if you raise the ISO value of your camera.

As an additional tidbit of information, the reason old digital and cellphone cameras have those speckles is that raising the ISO setting is the only way a camera can compensate for low-light conditions.

Since cellphone cameras do not have an aperture and adjustable shutter speed, and they only have low-powered (and mostly cheap) camera sensors, the only way that those cameras can control the amount of the light they can take in is to raise their sensors' ISO setting.

Well, they do have adjustable shutter speed or exposure time, but they are unlike from the regular DSLR camera. The quality of the images in cellphone cameras improved when better exposure time setups were introduced. That happened when cellphone hardware became a bit powerful.

By the way, photographers often do not want to change their cameras' ISO setting if possible. ISO 100 is often ideal for almost any kind of situation. You will only need to change it if you really need to compensate for the light badly or you want to avoid the side effects of aperture and shutter speed.

However, if light is the problem, it will be best for you to fix the light source instead or place your own light source if you

could. As mentioned before, photo noise is generally unwanted in photographs. Their presence in pictures is mostly for artistic and stylistic reasons.

The most you can do with ISO setting, which this book will recommend, is around ISO 200 to ISO 400 if you are shooting indoors with no natural light. Going way beyond those settings will make the noise apparent in your photos.

On the other hand, another way to compensate for light with touching the three settings is to use a flash. Flash is often discouraged, especially if you do not have reflectors or if the flash you have is not remote. It often produces an unnatural look on the subject and the lighting.

Of course, some photographers have techniques on how to prevent the destructive effects of flash in photos. Alternatively, they often resort to image editing applications such as Photoshop or Light Room to fix the unnatural lighting that flash creates.

Again, do note that the side effect of higher ISO settings can be really damaging to your photos. Yes, it can be a bit crisp, but there will be unwanted information that you do not certainly would want. Even with image editing programs, removal of noise is tricky, difficult, and often creates more destruction on a photo's image quality.

Anyway, if you are just taking pictures for fun, you can just ignore these warnings. But if you want to go pro or become an expert hobbyist photographer, please keep these warnings in mind.

Another thing, of course, is that once you go beyond the basics be stated in this book, feel free to choose the style and tips that you want to keep. Do not be chained to some photographer's advice on how he does things.

Only take these things as advice and guides, and do not let it restrain your creativity. After all, there is no one good setting

for every shot. And the judgment on what or where you will take your picture will be up to you.

Shutter Speed
When it comes to shutter speed, the side effect it brings when you raise its value is that it can produce blur — motion blur.

How can shutter speed generate blur? Well, the reasoning behind the blur production when you increase the shutter speed duration is camera shakes.

Since your camera actually combines multiple images and information that it takes every split second, everything it can see while the shutter is open will be included in the final image.

So, if your subject moves or your camera shakes, the camera will capture the movement, and combine it with the still pictures prior to the movement. It is kind of confusing, but the result is a blurred image — or a photo accompanied by motion blur.

Of course, by default, camera shutters open and close fast. It only takes a split second after all. But raise your camera's shutter speed to half a second or a full second and you will easily generate motion blur, especially if you are not using a tripod to put your camera down in one place and save it from your shaky hands.

Shutter speed is a setting you will only need to tweak or change when the situation arises.

For example, if you are moving and your hands are shaking a lot, then you should settle on a faster shutter speed. With a slower or longer shutter speed, the motion blur will creep in to your photo, as mentioned before.

When you have a tripod or if your camera has a camera shake stabilizer (which sometimes can make photos a bit fuzzy and offset), then feel free to use any shutter speed setting that will be ideal for the type of photo that you want to achieve.

Pro Tip

It will be best for you to experiment with all the settings that you can think of. Always take test shots. Take note of the settings you have mixed and matched. Then review all your test shots and see which one of them looks great for you.

And as you might concluded during the previous sections, most photographers often leave their ISO setting alone. Typically, it will be set on ISO 100. The usual setting they love to tweak is the aperture when controlling the light in their photos.

On the other hand, to solve some of the side effects or fix the light on the scene, they often leave their camera alone, and do some handiwork. They add lights, reflectors, and some even wait for the sun to be on the right place at the right time.

Alternatively, always be mindful of your distance from the subject. Do not hope that you can take the best pictures on the same spot. Do not expect that changing the focal length, lens, and aperture setting can let you arrive with the best picture and angle. Use your feet. Move. Do not forget that.

Chapter 6: Auto Mode

Of course, do not be afraid to make adjustments in your camera settings. But sometimes, in photography, time is essential. There will be times that you will be on a tight spot and you will be able to capture a scene that will be over in a second.

It often happens in photojournalists. It is also common in wedding photographers. Sometimes, they want to capture the sunset together with the couple. And they only have a few minutes before the sunset's light will disappear.

On the other hand, timing could be everything for landscape photographers, especially those ones who love to take pictures of places during the golden hour (sometimes referred to as the magic hour), the time when the sun rises and set and gives a golden hue on the scene.

If you were put in that kind of situation where time is valuable and you have no time to set your camera, you can just use your camera's auto settings. Take the shot. And pray.

Aside from the common camera features that you can adjust, you can rely on your camera's auto mode to set itself up and prepare you to take a good shot.

However, do note that, despite Auto mode sounds like the camera will do all the work, you still have the power to influence your camera's setup. And you can do that by using and setting some of its simple features.

One of them is light meter. The light meter is not only built for measuring the amount of light your camera will pick up. Aside from that, the light metering feature will enable you to set on how your camera will behave according to the lights available in your scene.

There are multiple light metering methods or modes. Each mode has its advantages and use. And with ample knowledge about their uses or their behavior, you can easily control the exposure levels when you are in auto mode.

The following are the light metering modes that are usually present in cameras and are used commonly by photographers:

Center Weighted Metering Mode

With the center weighted mode your camera's light meter will give more emphasis in light that can be spotted in the center of the viewfinder or your camera. For example, if you focus your camera in a man's face and the man's face is in the center of the viewfinder, the center-weighted mode will base the auto mode's setup according to the amount of light present on the man's face. If there is too much light on the face, the camera will tune down the golden triad settings to produce a darker photo.

To be precise, most light metering modes or most cameras will give consideration to the center with center weighted mode. If a camera's on center weighted mode, it will give 70% focus on the center of the scene. The remaining 30% will be given to the elements — usually the ones on the image's edges

Just like the example before, center weighted mode is often use when taking portraits. Obviously, is the best light metering mode to use in order for you to emphasize on the subject matter that you are taking if you want it to be located in the center of your photo.

Pattern/Scene Metering Mode

It is also called as scene bases metering mode. However, take note that different camera companies or brands of cameras have different names for pattern light metering mode or scene base metering mode.

Nikon calls it 3-D color matrix metering. Canon calls it evaluative metering. In Olympus cameras, it is called digital

ESP metering. And in Pentax and Sony, it is called multi-segment metering.

What it does is that the camera will divide the image into patterns or rectangles. The light will be grouped in multiple small boxes or areas. Because of these boxes, the they it makes the pattern looks like a pattern. The camera will judge or process the amount of light by considering all the lights in those boxes.

Depending on the camera or the manufacturer of the camera, the pattern light metering mode may behave differently. Some brands will perform a lot of analyzing on the image and some will just go over it and just determine where the lights are coming from.

Unfortunately, most camera makers do not actually expose the algorithms they use in order to achieve the effects of their own brand of pattern light metering mode. Typically, pattern light metering mode is recommended to be used in everyday photography, especially if you do not have time to adjust the camera for the light sources in the three settings.

Actually, with pattern light metering mode, the camera will adjust itself, and judge what is the best course of action or setting will be appropriate for the type of image that you will take

Spot Light Metering Mode

Another light metering mode that you can take advantage of is the spot metering mode. With spot metering mode, you can set the camera to focus on the center on a certain area.

Instead of just providing a huge chunk of focusing on the scene or patterns, it will only focus on one spot that you can indicate. Unlike center weighted, it provides 100% focus instead of the 70%.

With the spot metering mode, you can use or make the light metering mode to focus on an area that you want to basis of

the light source in your photo. Because of that, you have full control on letting the camera know which elements produce a lot of light.

For example, if you are shooting a light bulb in you can just set the spot metering mode to focus on the light bulb itself for you to have better control on the light intensity that the scene has.

Unfortunately, unlike other light metering modes, spot metering can get confused when they are faced with subjects with a lot of other light sources.

Chapter 7: Landscape and Nature Photography

One of the most important things you can learn is how to do proper Landscape and Nature Photography. There are certain things you need to understand, and these are the following...

On Camera Flash

On-Camera Flash is a feature of most digital cameras these days. This feature pops up when it's needed, or when you know some light is needed in the scene, just like what's shown below:

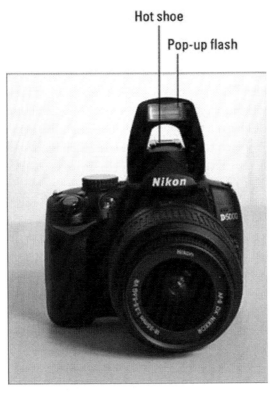

http://media.wiley.com/Lux/25/284725.image0.jpg

What you have to remember is you have to prevent yourself with using this on wildlife photography because it easily startles the animals. For other nature photographs, however, you can use the flash, so the exposure could be based both on the settings of the camera, and on ambient light, as well. Auxiliary flash units could also be used on various surfaces so your photos would come out looking like pleasing light sources have been used on them.

Wireless flashes are also supported by some modern-day DSLRs, which means that control is not necessarily connected to the camera itself. The sensor also acts somewhat like an infrared beam that signals when it's needed—and can also be used multiple times.

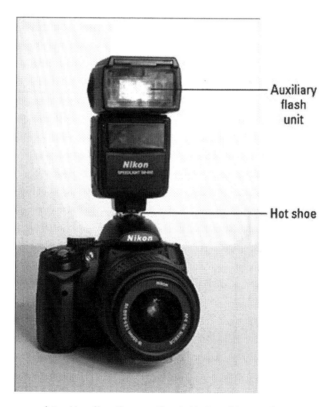

Auxiliary
flash
unit

Hot shoe

http://media.wiley.com/Lux/26/284726.image1.jpg

38

Making Nature Photographs Interesting
It is important to take note of the Notes of Composition when it comes to Nature Photography. This means you have to incorporate selective focus, patterns, shapes, color and light. From time to time though, remember that you can break the rules. In short, you have to take photographs depending on what you're taking a picture of—and not based on the rules themselves.

Sometimes, you'd find that it's better to put your subject in the center—and blur what's in the background. For example:

http://media.wiley.com/Lux/04/285004.image0.jpg

Here's what you can do:

Use long-focal telephoto lens. Use wide-angle lenses for grand landscapes, but you can also choose to use lenses that are 100mm or longer for this. This is perfect for barks, patterns, and textures.

Make use of a level-horizon line. For most pieces, you should use a level-horizon line. Break rules when you see animals.

Always think of how your subject would look into the photo. As they say, you have to leave your subject some room to look into the photograph, especially if you're taking the photo from a distance.

Shoot from an angle that's unorthodox. You don't always have to take photos from eye level. Try using an unorthodox front of view. Look for where noise is coming from, and try to check if animals would look at you before taking their picture.

Other Tips

Emphasize the Subject

Say, you're shooting a portrait. Of course, you want people to focus on the subject, instead of the background, right?

So, make sure you have used the right ISO, aperture, and shutter speed settings. Refer to Chapter 1 for further details.

https://farm8.staticflickr.com/7337/9397600663_66acf1015c_z.jpg

Then, make use of framing. You don't actually have to use real-life picture frames, or edit the photo just to get a frame. Basically, you can use natural arches, barn windows, stones, leaves of trees, branches, and the like, just so they would point towards your subject. Elements of Contrast help, too. Examples include sunlit mountains and silhouetted trees, or two people with the shadows of the moon around them.

Also, try to make use of light to focus on the subject. Just make sure you do not take photos against the light—just subtle light is already okay.

Make Use of Repeating Patterns

You get to attract people to check out your photos when you use repeating patterns, mainly because people are naturally attracted to patterns. For example, take photos of butterflies, of the ripples caused by the river, lily pads floating on water, or a picture of the sandy shore.

41

http://lh3.ggpht.com/_3ggnNfdZJT0/SkM0L6VY9yI/AAAAAAAAAXE/up
hSBRc6FMc/StairsatADNOC_thumb2.jpg?imgmax=800

When you use repeating patterns in your photos, you also get to create a sense of balance and harmony—instead of focusing on the chaos.

Find a Great Foreground

Your foreground is responsible for adding depth to your photos. They can even make chaotic scenes look simple, and eye-catching.

For example, instead of just taking a photo of the sea, you also should include the shore—and the sun or moon behind it, too. More layers equal more editing fun, and also mean your photos are actually realistic.

https://s-media-cache-
ak0.pinimg.com/736x/4b/bb/eb/4bbbebe7c992019176b3a9c15d5110c4.jp
g

Use Visual Elements

Visual Elements can definitely get people's attention.

This means that you have to make use of lines, and curves in a single photo. Again, it's all about layering, and shape progression. When you have these elements, your photos turn to be powerful.

For example, instead of just taking a photo of the river, why not add the cliffs behind it, too? Or, you could also take photos of rocks and trees nearby. This way, your photos wouldn't just have a single element on it—and you'd give people a lot to see, which would of course, make them want to check your other photos even more.

Photographing Animals

As for other animals, let them blend in their natural habitat before photographing them. Don't try to chase them—you do not want them to run after you! Just be patient, and you'd get great photos.

When it comes to wildlife, always go for shallow Depths of Field so that you could create amazing close-up shots, and avoid distractions in the background.

http://images.fineartamerica.com/images-medium-large-5/overcast-day-at-the-portland-head-light-at-lands-end-photography.jpg

Think of an Adjective

Another great nature photography tip is to think of a certain adjective that depicts your subject.

For example, mountains are strong. Birds are free. Clouds are fluffy. The vegetation is lush. Flowers are beautiful, and so on.

Now, once you have that adjective, make sure that you keep it in mind as you take the photograph, so that you'd be able to invoke the said adjective to your output. This would then make the photos look more natural.

Appreciate Overcast Days

Don't think that just because the day seems to be dreary then your photos would turn dreary, too.

Sometimes, overcast days could lead to increased color saturation, mainly because of light diffusion. Focus on that.

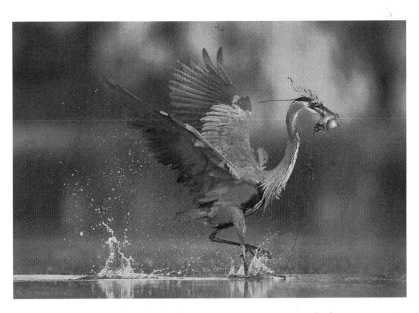

http://webneel.com/daily/sites/default/files/images/daily/04-2013/13-best-bird-photography-by-christopher.jpg

Photographing Birds

Birds are some of the nicest creatures to take photos of. A good tip would be to make sure that you make use of natural backgrounds, and avoid taking photos of them when they're near electric poles, houses, wires, and the like.

Take photos of them in their natural habitat so your photos would work.

It's also best to use a 400mm telephoto—or even greater—when trying to take photos of birds. As for tripods, use those that are 300mm and under.

The Skies

Never use metered settings on the skies because you'd probably just cause the whole photo to be underexposed. This is because the sky is naturally bright to begin with.

Lightning

Patience is needed when it comes to taking photographs of lightning.

As they say, no one knows when lightning will strike—so you do have to set shutter speed fast, and be ready when it happens.

All in the Details

If you're trying to photograph details, such as bee hives, seed pods, dandelion flowers, and the like, make sure that you try various angles. This would make for better composition, and would also allow you to appreciate the photo in different ways.

http://stupiddope.com/wp-content/uploads/2014/09/ryanstruck1.jpg

As for wildflowers, take note that it's best to take photos of them during sunset because the sunlight would give the flowers a certain kind of glow.

For plants, it's best to take photos of a bunch of them. Dew also adds texture, as well as raindrops or snow, during winter.

Do it in the Morning

When it comes to nature photography, it's always best to do it during early mornings because then, you'd have the place to yourself, and you could avoid throngs of people who might distract you while you're trying to take a photograph.

Chapter 8: Personalizing Your Photographs

Switch off On-Camera Flash

You may think that turning flash on would make your photos look better in the sense that they'd be brighter, but the thing is that it often just creates the effect of harsh light onscreen. It also makes the photo unrealistic. After all, you could always edit photos these days, but it's harder with the flash on.

Try Using Manual Mode

The problem with most people is that they tend to just use their cameras on automatic mode.

Well, when this happens, chances are, the photos would just come out to be mediocre. And, that's not really a good thing because if you're trying to put out excellent photos, you have to keep in mind that you have to tweak the settings yourself. Mostly, this just has a lot to do with the Exposure Triangle— and if you've properly read what was written above, you'd definitely have no problems with this.

Experimentation Is Key

As a beginner in the photography game, you'd have to keep in mind that if you want to know what you're really good at, you do have to experiment a lot. This way, you'd know what you're comfortable with, and you'd see what speaks to you the most.

Still Life, Wildlife, Sports Photography, Candid Shots...You have to try them all out, and see what best fits you.

Also, make sure that you do not only experiment, but you actually devote your time to taking pictures. In short, you have to be consistent, and you have to make it a part of your life.

Remember, practice makes perfect—and if you want to be skilled at photography, you do have to give it time.

Shoot Raw

RAW files are best for editing. This is because the colors, texture, and structure of the photos are kept intact, so that in turn, when you process them in *Photoshop* or other photo editors, you'd be able to get the results that you want.

Also, once you save files as .JPG, it'll be harder for you to process them because they're kind of intact already—which means the photos aren't executable anymore, but rather independent files already.

Try Prime Lenses

Don't worry about the price—there actually are some pretty affordable ones on the market. You could already cover a good range of photos, and you could cover even the harshest weather conditions if you have a good prime lens with you.

50mm Prime Lenses are the most recommended ones, especially those made by *Sony, Nikon*, and *Canon*. This will also make it easy for you to zoom in on your photos, and be able to put out photos that have excellent quality. Prime Lenses are always good starting points.

Try Printing Your Images

And do so in a large-scale manner.

Aside from being able to see your photos up close, and being able to feel them in your hands, it's also a good way of seeing their clarity—and their whole quality, for that matter.

Basically, it's a way of re-assessing whether you're doing the right thing, or if you have to make necessary adjustments.

And, don't forget to Read the Manual

This should be a no-brainer.

Not reading the manual is like not taking the time to understand your device, and just throwing yourself somewhere without knowing what to do, and what it has in store for you.

Also, you have to keep in mind that not all cameras are created the same. Even if you've tried using a friend's camera before, that doesn't give you the right not to read your camera's manual anymore.

Remember that it's best to understand things on the get-go, instead of being clueless about everything. When you read the manual, you'd get basic knowledge about how to operate your camera—and then you can just apply everything you'll learn about photography after.

In the next chapter, you'd learn how Photoshop and Instagram could turn your photos into masterpieces. Read on and find out how.

Chapter 9: Tips for Various Events

Portraits

If you're not doing it in a studio, shooting at a natural setting would be good.

Set image to 114 x 14 inches, to be able to fill the frame, and create interesting visual focal point.

https://cdn.fstoppers.com/styles/full/s3/lead/2014/11/fstoppers-natural-light-dani-how-to-retouch-dof-bokeh-sharp-facebook-female-fashion-nyc-model-portrait1.jpg

Make use of vast open spaces. For this, you can use Canon EOS 5D-70/200 with 2.8 IS Lens. Set aperture to 2.8/f, and use 200 mm lens.

Weddings

Use lenses that have wide angle or wide-telephoto zoom options and always set aperture to 2.8/f or even higher. This

works best not just for church or garden settings, but also for the receptions, as well.

http://www.visiondude.com/wp-content/uploads/2016/03/wedding-photography-pose.jpg

As for focal length, it would be good to make use of 70-200 mm focal length—which is perfect for when the bride is walking down the aisle. You could also use 200/2.8 standard zoom, or even 300/2.8 and set aperture to 2.8/f.

Always keep 2 to 3 prime lenses with you. The faster, the better. Set aperture to 2.8/f or 1.4/f, and use lenses in the 28/1.8, and 85/1.5 settings.

It would also be good to make use of handheld flash meters, optical triggers, flash triggering devices, softboxes, umbrellas, and light stands, as well.

When using strobe lights, make sure you have stand lights on hand, too.

https://iso.500px.com/wp-content/uploads/2015/12/macro_cover-1500x1000.jpg

Macro

For Macro Photography, you need to make use of special cameras that have Macro settings, such as Canon EF-S 60mm or Canon Digital Rebel XTi. Set lens to 1:1 to create life-size photos.

You could also make use of close-up lenses because they don't require any special exposure corrections, and they're relatively cheaper, too.

Take note that Macro Zoom lenses don't have the same effects as Macro Lenses. You still need to get Macro Lenses to give you the results that you need.

Always choose those with 50 to 200mm focal length so that you'd get clearer focus.

Interiors

When shooting in interior settings, you have to be careful of light because it's generally darker indoors than outdoors. It's

okay to make use of flashes for these settings, as well, so that you won't have to bring tripods with you anymore.

http://vrayworld.com/media/tutorials/photography-how-to-shoot-3d-interior-photography-beginner/4.jpg

When shooting spiral staircases, always stay at the top so you'd have high vantage point to create the effects that you want. Use 35mm lenses for this, too.

Make the photos look as wide as possible. You have to create airy effects for interiors to make them look appealing.

Highlight details by using 50mm lenses, or even longer.

Make sure that shutter speed is fast, especially when you have a lot of people around you.

Street

Volume is essential for street photography. You need to make sure that you're able to show the reality of what's happening in the streets. Basically, what you can do is to take photos continuously, or at least, for a week or so. This way, you'd be able to tell a story.

https://cdn.tutsplus.com/photo/uploads/legacy/516_streetroundup/4.jpg

Use 20mm full-frame lenses or 35 mm cameras so you could shoot at wide angles, and make sure that ISO is low.

Nature/Wildlife

As mentioned earlier, you should choose manual over automatic. You have to set focal points and exposure, because you're the only person who knows what kind of story you want to tell.

Try cameras with mirror lock-ups, and DOF point of views, so you could easily see whether you've taken the right photo or not.

Make use of a complete camera system. Usually, these are 20mm lenses, with 2.8/f aperture.

Autofocus and auto-exposure really aren't needed.

Try 75-300 or 100 to 300mm as your starting lens, but if you feel like this is too short, go for 400 mm ones instead.

Teleconverters could give you great results, but they cost a lot, so you do have to be prepared for that.

Don't use telescopes as telephoto lenses. The results are just disappointing. You can just use 3rd party lenses, if desired.

Tripods are essential!

Studio

For studio photography, decide whether you want a studio that's floor based or ceiling based. Ceiling based studios make use of roller systems, like they do back in the olden days, and lights are easily positioned in rectangular settings. Meanwhile, floor type ones have background supports and lightstands—which are pretty much used these days.

Bigger cameras mean you'd only have to use lower apertures, which are perfect for portraits and head and shoulder photographs.

Using hot lights is also okay, since you won't have sunlight around. Make sure that you use one with 500 watts, and as for strobe lights, go for those 2000 watts and over.

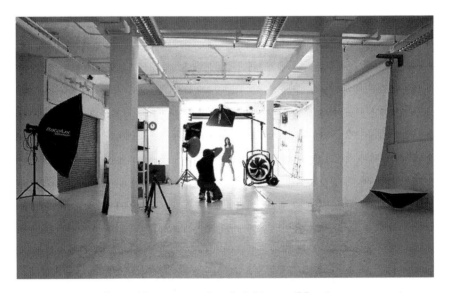

http://www.pawelspolnicki.com/blog/wp-content/uploads/2013/11/photography-studio-hire-london.jpg

Warm lights, of course, produce warmth for your photos—and are often used in major studios. This also means that they cost much.

Cold lights are just another term for artificial lights, or electronic flashes, but these will also make it easy for you to view your photos on LCD monitors, which make for easier editing.

Use tripods to support the camera.

Choose popular lighting systems. This means that they're actually reliable.

Use seamless paper for your background, so that the main focus would really be on the subject.

Chapter 10: When Should You Take Photos?

So, when is it best to take photos?

You know, it actually depends on the subject, and on settings used. Take a look at descriptions of different times of the day below so that you'd know what to use for your photos.

Pre-Sunrise/Dawn

Shooting at dawn would give your photos a bluish, cold glow—and you'd also notice that shadows wouldn't be prevalent.

http://d310a9hpolx59w.cloudfront.net/product_photos/166817/RedDawn
_original.jpg

As mentioned earlier, nature photography might be best done at dawn. It's also recommended for those people who would like to shoot without being disturbed by anyone.

Take note that most photos shown in Car/Sports magazines are actually taken at dawn!

Sunrise

Shooting at sunrise would allow you to get people's attention.

http://webneel.com/daily/sites/default/files/images/daily/04-2013/7-best-sunrise-photography.jpg

This is mainly because photos taken during sunrise are full of warmth, which makes them definitely interesting. They also work best for black and white photography.

The Golden Hour

This is the hour before sunrise, and also the last hour before sunset, where the skies turn into various shades of pink, purple, or yellow. It's pretty much a sight to see!

Taking photos during the Golden Hour—also called Magic Hour—will provide you with photos that have soft glows and diffused lighting.

Photos taken during this time o the day also have low contrast and give them this warm, pleasing glow. Because of that, the photos also turn out to be full of depth and texture, which are exactly what you need in a photo.

Peace is also achieved by your photos when you shoot in the Golden Hour. This is also recommended for outdoor or nature photography, especially when taking pictures of the skies.

So, you can say that this is probably the best time to shoot in a day, but then again, it always depends on the situation.

http://greatinspire.com/wp-content/uploads/2013/05/Mind-blowing-morning-photography-16.jpg

Morning

You can also expect light to remain calm, and best for photographs, until mid-morning. If you're trying to do landscape photography, it's best to do it during these times so that you'd also get photos with amazing color visibility, and neutral tones, too.

Mid-Day

Shooting during Mid-Day is a big no-no. For one, the photos would just turn out to be against the light, mainly because the sun is at its peak during this time.

http://www.photovideoedu.com/Portals/0/Lighting/MOC_Zuckerman_o
n_Landscapes_Midday_Lighting_4-6.jpg

Then, the photos would also get dark shadows because of the position of the sun (but if you're going to shoot in a studio, then that's fine)

If you really need to shoot during this time, look for some clouds, or try to shoot exactly after the rain has fallen.

Afternoon

Shooting during afternoons is also okay as it gives you neutral tones and great visibility, but the output would turn out to have a much warmer feel.

http://www.phototraces.net/wp-content/uploads/Travel_Photography_Blog_Montreal_201201022.jpg

Sunset

When taking photos during sunset—and we're not talking about the Golden Hour here—you have to make sure that you bracket your shots, and that you shoot at the side where the sun is.

However, sunsets are perfect for when you want to take silhouette shots. You can do so by letting your subject stay directly in front of the sun. Take the shot with no light reading involved.

Another thing to keep in mind when taking photos during sunset—especially when you're on the beach—is that you should make use of the "Golden Hour", also known as the "Magic Hour", or the time before the sun actually sets. This way, you can get all shades of pink, purple, or orange up in the sky to work for your photos!

Always shoot in Aperture Priority Mode and make use of Single Shot Focus so that the landscapes would really remain "still"—and so you could take that perfect shot!

Dusk

You'd be able to capture a lot of amazing colors during dusk, especially when you make use of a tripod to aid you.

http://advice.jessops.com/media/7570/hero_expert_dusk_photography.j
pg

Basically, you will see various shades of brown, and purple shades turning to orange. It's perfect for taking pictures of cityscapes, especially with the kind of light you'll get during this time.

Night shots are usually actually taken during dusk because there's still some light in the sky—and stars, too! However, keep in mind that there isn't much ambient light at night—so don't go to the darkest, most desolate spots. If there are stars—and the moon—around, make use of their own light, too. This way, your photos will be interesting!

In short, it's best to take photos during the golden hour, morning, or dusk. Otherwise, just make sure that you'll be shooting in a studio, and that you'd set your camera the right way—and you're all set!

Chapter 11: Beautify Photos for Photo-Sharing Sites

Next, it's time to learn how to edit photos on *Instagram* and other photo-sharing sites, whether by using Filters, and other apps that would make those photos look better.

As you well may know by now, Instagram is quite popular for being the social media site that's perfect for photography enthusiasts. Hence, it's a no-brainer that learning how to make photos look great on Instagram is surely important.

Let's begin with the Best Photo Apps that you can use to take amazing Instagram photos.

Best Instagram Photo Apps

So, which apps should you use to take better Instagram photos? Here's rundown.

1. VSCO Cam

Since its introduction, *VSCO Cam* has already been a favorite of many, mainly because it brightens photos, gives them more depth, and the fact that the app also has an amazing selection of filters that you can use, too. More so, it's quite flexible in such a way that you get to customize your photo's exposure— even double exposure—even more. You can take a look at the sample photo below for better clarity.

As you can see, the photo is too fair, and not something you'd really want to post right away. However, you can use VSCO to adjust exposure, so you'd get a clearer picture, and then use filters to make it all the more appealing. Afterwards, you'd get an end photo like the one below.

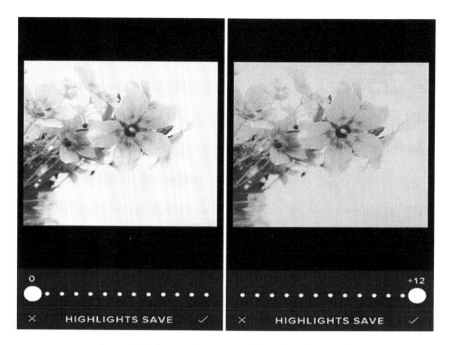

http://iphonephotographyschool.com/wp-
content/uploads/VSCO-Cam-iPhone-App-41.jpg

2. Snapseed

Snapseed is best for editing brightness and contrast, and everything else that has to do with color—without making the photos look artificial. As you well may know by now, natural-looking photos definitely are still the best.

Take a look at the sample photos below to see what Snapseed can do.

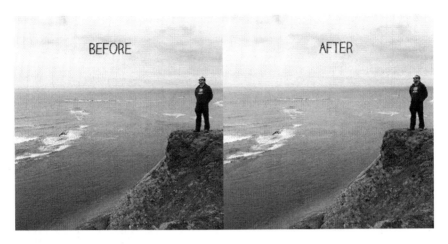

http://cdn2.hubspot.net/hub/513577/file-2910466775-jpg/blog-files/snapseed.jpg?t=1434132870220&width=700&height=350

As you can see, after using Snapseed, the photo gets to look more vibrant—more believable, and definitely something that's worth posting!

3. Pic Stitch

Pic Stitch is used for times when you have a lot of photos at hand, but do not really want to flood your Instagram dashboard with them. In short, this app allows you to share a bunch of photos at one—just like a collage, but something cleaner—just like the example below.

69

http://cdn2.hubspot.net/hub/513577/file-2910466880-jpg/blog-
files/photo-2-
e1410178287517.jpg?t=1434132870220&width=400&height=400

4. Camera+

Camera + works like VSCO in such a way that it allows you to tweak your photos' exposure, especially when using an iPhone for posting.

5. SquareReady

Ah, *SquareReady* is really handy, especially when Instagram is concerned because it allows you to crop your photos into squares—which are of course, the photo shape that's accepted

on Instagram—without ruining the quality or composure of the photos.

In short, you shouldn't worry about people getting cut out of the photos. The example below shows what happens when you cut a photo directly on Instagram.

http://cdn2.hubspot.net/hub/513577/file-2910466890-jpg/blog-files/photo-21-e1410178487983.jpg?t=1434132870220&width=400&height=511

But, if you crop on *SquareReady,* you'd get something like the one below...

http://cdn2.hubspot.net/hub/513577/file-2910466930-jpg/blog-files/photo-1-e1410178568822.jpg?t=1434132870220&width=400&height=519

See? No one's face was cut off—and everyone's in the frame! Now, that's really something worth downloading.

6. Overgram

Meanwhile, *Overgram* is about times when you want to add text to your photos—without making the photos look like someone put them on MS Paint or something. Basically, you'd get end results like the one below.

http://cdn2.hubspot.net/hub/513577/file-2910466840-jpg/blog-files/photo-3-e1410178234684.jpg?t=1434132870220&width=400&height=400

7. Hipstamatic

And finally, you have *Hipstamatic*, which is basically perfect for those who want their photos to have this retro, vintage feel—without editing!

Working on Filters

Filters. Filters Everywhere.

You know, Instagram is full of filters—and the best thing you can do with them is know exactly when you have to use each of them. After using one of those apps given above, you can just use the filters given below. And after doing so, you'd see that you're actually able to post photos that are swoon-worthy—and that people would certainly be in awe of!

Now, here's a rundown of how and when you should use each of the Instagram Filters out there. Read on and find out how!

Amaro

Amaro makes the center of the photo as the focus and gives more light to your image. You'll notice Amaro more if you have taken an originally dark photo.

Make sure to use it when you want your photos to have an aged feel.

http://www.simplyzesty.com/wp-
content/uploads//2012/11/Amaro.jpg

Rise

Rise is often a favorite of many because of the fact that it gives photos softer lighting, which then produces an enviable glow. It has a yellow tint, and warm temperature, and is best for taking close-up shots.

http://www.simplyzesty.com/wp-content/uploads//2012/11/Rise.jpg

Hudson

If Rise makes photos glowing, Hudson on the other hand, makes them icy. With cool tints and heightened shadows, you can expect your photos to have this cold feel.

It's best to use Hudson when you're taking outdoor shots, whether of people, or buildings, and the like.

http://rack.1.mshcdn.com/media/ZgkyMDEyLzA3LzE5LzA4XzU3XzA4Xz
M1M19maWxlCnAJdGh1bWJWIJODUweDg1MD4KZQlqcGc/f927e3d5.jpg

X Pro II

X Pro II makes use of golden tints, with high contrasts, and vignette edges. They give your photos some warmth by making sure that the colors are vibrant.

You can use this whether indoors or outdoors, as long as you want your image to have strong colors in them.

http://www.simplyzesty.com/wp-content/uploads//2012/11/XProII.jpg

Sierra

Sierra is great because it dodges the center slightly by means of low contrast and high exposure, which then makes the photo look a bit cloudy, and gives it that dreamy feel.

Use Sierra when you want to make your photos look soothing and calm.

http://www.simplyzesty.com/wp-content/uploads//2012/11/Sierra.jpg

Lo-Fi

Lo-Fi makes use of warm temperatures with high saturation that then add strong shadows and colors to the photos you take. It's often best for food photography.

http://rack.3.mshcdn.com/media/ZgkyMDEyLzA3LzE5LzA4XzU3XzA5Xz
g1X2ZpbGUKcAloaHVtYgk4NTB4ODUwPgplCWpwZw/24c72030.jpg

Early Bird

Early Bird uses blurred and faded settings that make photos look old, and give them a vintage feel. While it uses warm temperature, the effects actually end up cool, mostly because of sepia tints and vignette corners.

It's best to use this filter when you want to invoke the past into your photos, and make them look cool.

http://media.tumblr.com/tumblr_lvsin2USVz1qe3vcj.jpg

Sutro

With blurred edges, shadows, and dramatic highlights, Sutro makes your photos look smoky, mainly because of the use of brown and purple tones. It kind of adds a sinister feel to your photos, so again, it's best to use the filter when you want your photos to have a vintage and gothic feel.

Toaster

As the name suggests, your photos get to have a burnt look when you use this filter. Again, it adds a vintage and aged feel, mostly by using sherbet tints, vignette edges, and a burnt center.

Use it for photos taken in summer, or if you want your photos to look dramatic.

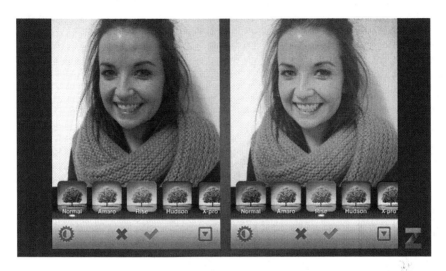

http://nunoricardodasilva.com/wp-
content/uploads/image/Rise.jpg

Brannan

Brannan is another high-contrast filter that uses high exposure, and metallic tints to provide your photos with darker, grayer appearances.

It's best to use this filter when you want to soften neutrals, or when your photos have strong shadows, too.

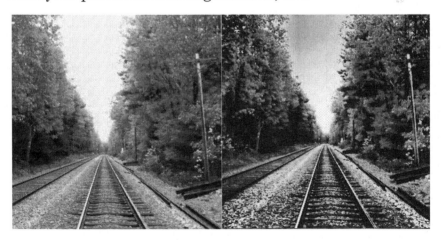

Inkwell

With Zero Color Saturation, Inkwell is the easiest way to turn your photos black and white!

Use it when you want to turn your photos black and white without any editing done! It's also best for photos with prominent light and shadows, too.

 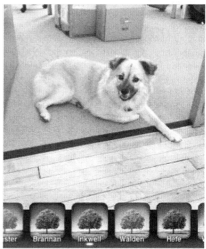

http://rack.2.mshcdn.com/media/ZgkyMDEyLzA3LzE5LzA4XzU3XzA5XzEyNF9maWxlCnA
JdGh1bWlJODUweDg1MD4KZQlqcGc/20e873af.jpg

Walden

With yellow tint and high exposure, this filter is almost similar to Lo-Fi, but it's definitely less dramatic.

Use it when you want your photos to become more vibrant.

http://www.petapixel.com/assets/uploads/2011/09/Walden-original-2.0_mini.jpg

Hefe

Hefe makes use of high saturation, high contrast, and vignette edges that make the photos more vibrant, but with less exposure.

Use this for photos that are already vibrant but that you want to enhance even more.

Valencia

Valencia is a filter that uses warm temperature mixed with high exposure that makes your photos look retro by giving it a faded, Polaroid-like quality.

Use it when you want photos to look antique without washing color out, and while making sure that the photos stay delicate and accurate, when color is concerned.

http://cdn.vogue.com.au/media/file_uploads/1/1/3/0/11377-1.jpg

Nashville

True to its country roots, Nashville makes use of warm temperatures mixed with low contrast and high exposure, which adds a pastel tint to your photos.

Use this filter when you want to give a vintage and nostalgic feel to your photos.

1977

1977 makes your photos look retro by means of red tints and high exposure—similar to that of a Polaroid camera's.

Basically, you should use this if you want your photos to look like they were taken in the 1970's.

https://s3.amazonaws.com/livelygreendoor/2013/05/hot-air-balloon-instagram-upload.jpg

Kelvin

And lastly, there's Kelvin.

This filter uses warm temperatures with high saturation to give your photos a radiant, vibrant glow.

Use this for photos taken in music festivals, or for times when you want to add warmth to your photos.

http://nunoricardodasilva.com/wp-content/uploads/image/kelvin.jpg

89

Chapter 12: Enhancing Effects

Ah, the power of editing.

These days, almost everyone turns to *Photoshop* or *Instagram* to make their photos look even better. Is that a bad thing?

Well, not really. After all, photos are aesthetics, plain and simple—you have to make sure that they look their best, and that they're actually presentable.

That said, in this chapter, you'd learn everything you can about editing on *Photoshop* and *Instagram* and making those photos look their best!

Editing on Photoshop
Soft Haze Effect

Let's start with the Soft Haze Effect. Suppose your original photo is the one below:

http://ppimgs.s3.amazonaws.com/ps-haze-effect-1.jpg

1. The first thing you'd have to do is add Curves Adjustment layer, and then select Curves.
2. Then, edit the RGB curve as shown on the image below.

http://ppimgs.s3.amazonaws.com/ps-haze-effect-5.jpg

3. Now, you have to tweak the adjustment levels. Look at the space next to Output and change it to "6".

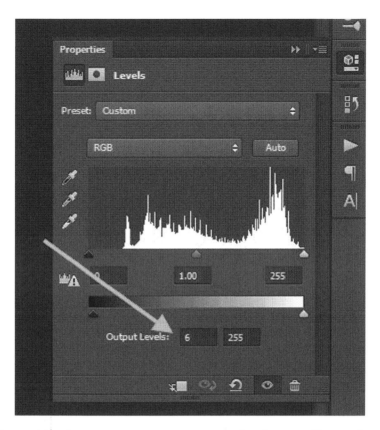

http://ppimgs.s3.amazonaws.com/ps-haze-effect-7.jpg

4. Then, select Red in the levels section.

5. After doing so, go ahead and pull the dropdown and choose Green. Afterwards, choose Blue, and change setting to "30".

6. Now, it's time for you to add the solid color adjustment layer. Look at the image below, and then select Color. After doing so, choose a color setting of #152b5d, which is basically the color of Dark Blue.

7. Layer it over with a shade of brown, or #96713d and set it as "Soft Light". Set Opacity as "20".

8. Now, add an adjustment layer of a gradient map. You have to choose the purple to orange hue, just as shown below:

http://ppimgs.s3.amazonaws.com/ps-haze-effect-12.jpg

That's basically it. After you do that, you'd get a result like the one shown below:

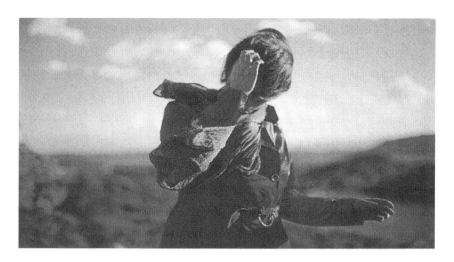

http://ppimgs.s3.amazonaws.com/ps-haze-effect-2.jpg

See the difference? Now, let's try to create a faded film look.

Faded Film Effect

A faded film effect gives your photos a vintage or rustic feel. Take for example the original photo below:

http://www.presetkingdom.com/wp-content/uploads/2015/06/12.jpg

It's kind of too bright, isn't it? Now, you can tweak that to give it a more classic appeal. Here's how:

1. Select the Curves Adjustment layer again. It's the button shown below:

http://www.presetkingdom.com/wp-content/uploads/2015/06/32.jpg

2. Next, Select Curves, and then make a curve-like line, as shown below, before setting hue/saturation levels to "40".

3. Now, adjust brightness/contrast levels, and push it to "-15".

http://www.presetkingdom.com/wp-content/uploads/2015/06/7.jpg

4. Now, you just have to work on your Gradient Map. Choose something that either fades to yellow (#fafb91) or that fades to blue, instead (#7691cc)

5. Let blend mode stay normal, but make sure to change Opacity to 10%.

Now, you're all set, and you'd get a photo that looks like the one below:

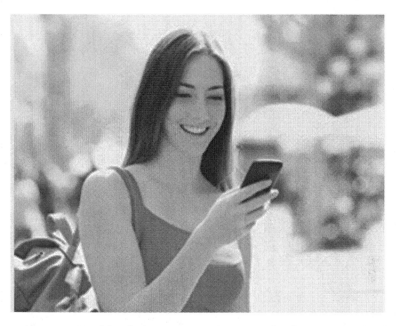

http://www.presetkingdom.com/wp-content/uploads/2015/06/62.jpg

As you can see, it's now muted, and there seems to be some texture on the background, too! Awesome, right?

Cinematic Effect

We've done the Faded Film Effect, so why not move on to Cinematic Effect?

A Cinematic Effect gives your photos this crisp texture, and colors that are overwhelming instead of underwhelming.

http://shutterpulse.com/wp-content/uploads/2015/06/13.jpg

Look at the photo above. That will be your original photo. Now, let's start working on it.

1. First, duplicate the background layer. After duplicating it, go to the Shadows/Highlights option, as shown below:

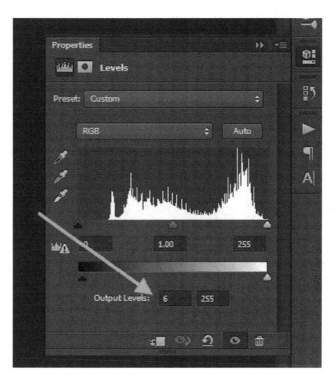

2. Then, open the settings. A dialog box would then pop up onscreen. Just turn the settings for shadow to the left to lighten it. Take a cue from this screenshot:

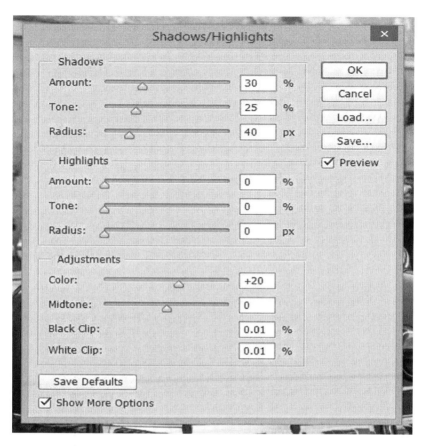

http://shutterpulse.com/wp-content/uploads/2015/06/33.jpg

3. Then, go ahead and sharpen the image by going to the unsharp mask option and then add another adjustment layer, and another curve layer, as shown below.

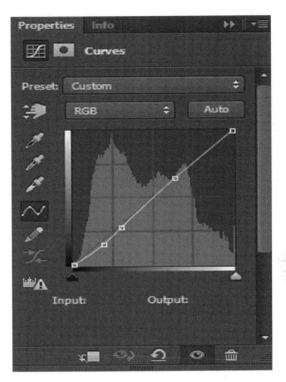

http://shutterpulse.com/wp-content/uploads/2015/06/62.jpg

4. Now, darken midtones, and adjust brightness and contrast. An adjustment of +15 would be good.
5. Next, it's time to adjust vibrance and saturation. Vibrance should be set to +10, and -15 would do for saturation.

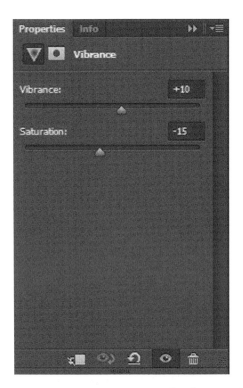

http://shutterpulse.com/wp-content/uploads/2015/06/101.jpg

6. Now, add another adjustment layer. This one would be for the photo filter. Change density to 35% after adjusting warming layer to +35, just as shown below.

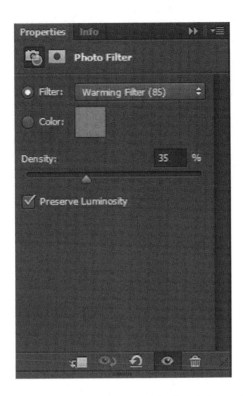

http://shutterpulse.com/wp-content/uploads/2015/06/111.jpg

7. Finally, it's all about adjusting gradients. Add a gradient fill layer, choose radial, and set it to 200% and 90 degrees so that you could form a vignette.

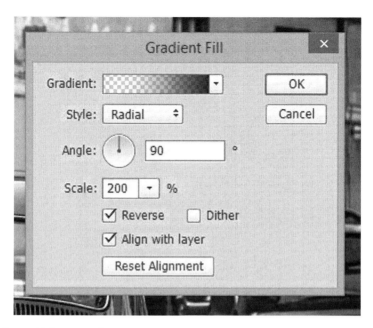

http://shutterpulse.com/wp-content/uploads/2015/06/121.jpg

8. Choose Soft Light for the Blend Mode and set 60 as the opacity. Just adjust it according to your preferences, if you want something stronger or softer.

9. After following the instructions, you'd get an end result like the one below:

http://shutterpulse.com/wp-content/uploads/2015/06/14.jpg

Tilt Shift Effect

Next, it's time for you to learn how to do a Tilt Shift Effect. This way, you wouldn't have to buy some tilt shift lenses—which could really be expensive.

The Tilt Shift Effect is done to give a photo the feeling of being a miniature model, much like what architects use. It also usually works on photos that were taken from a high vantage point, especially those with buildings, cars, and other infrastructures—just like the example below.

http://exposureschool-1582.kxcdn.com/wp-
content/uploads/2015/05/15.jpg

1. The first step to achieve the Tilt Shift Effect is to make
sure that you duplicate the background layer, for it not to
be destructed. Just go to **Layer>Duplicate Layer** and
then choose Convert to Small Object.

http://exposureschool-1582.kxcdn.com/wp-content/uploads/2015/05/24.jpg

2. Then, go to Filter, followed by Blur Gallery, and then choose Tilt Shift.

3. After doing so, you'd see lines form on your screen. Take note that those lines in the center determine your main focus, and the dashed lines will then get the blur or softening effect.

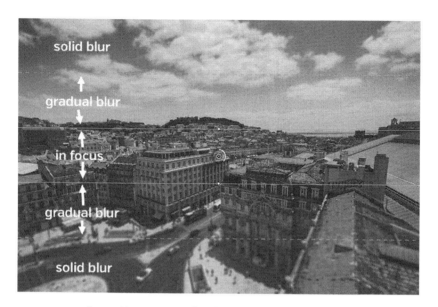

solid blur

gradual blur

in focus

gradual blur

solid blur

http://exposureschool-1582.kxcdn.com/wp-
content/uploads/2015/05/64.jpg

4. To edit, just drag those lines where you want them to be—while taking note that the photo still has to look realistic. No need to turn things upside down or so. It's your choice whether you'd want them to be close together, or go far apart, just so you'd know where your main focus is.

5. Set blur to 20px, and light range to 200 to 245.

http://exposureschool-1582.kxcdn.com/wp-
content/uploads/2015/05/102.jpg

6. Once the settings are applied, it's time to add vignette. You need this so the people would focus on the center of the photo. Just select gradient, and choose one that goes from being black to being transparent.

http://exposureschool-1582.kxcdn.com/wp-
content/uploads/2015/05/132.jpg

7. Scale to 175% and set to radial and then check Reverse.

http://exposureschool-1582.kxcdn.com/wp-
content/uploads/2015/05/141.jpg

8. Select Multiply for the layer's blend and choose 30% as the opacity. Adjust vignette some more, according to your preferences, if desired.

http://exposureschool-1582.kxcdn.com/wp-content/uploads/2015/05/151.jpg

9. After doing so, you'd get an end photo that looks something like this:

http://exposureschool-1582.kxcdn.com/wp-content/uploads/2015/05/16.jpg

Old Film Effect

Next, you're going to learn how to create an Old Film Effect. This is another one of those vintage-feel effects that would give your photos more depth, and make them look more appealing. Hint: Instagram Worthy!

Take a look at the sample original photo below.

http://llandscapes-ee1.kxcdn.com/wp-content/uploads/2015/04/19.jpg

1. The first thing you have to do is add the Curves Adjustment Layer, just by clicking the Curve Icon. You'd find this under the adjustments button.

http://llandscapes-ee1.kxcdn.com/wp-content/uploads/2015/04/32.jpg

2. Next, go ahead and adjust the green and blue curves. Lift the middle of the green curve just a bit, and then drop the right end of the blue curve. Look at the samples below.

http://llandscapes-ee1.kxcdn.com/wp-content/uploads/2015/04/42.jpg

3. Lift the left end point to adjust RGB curves, just as shown on the sample below.

http://llandscapes-ee1.kxcdn.com/wp-content/uploads/2015/04/52.jpg

4. Next, it's time to add a black and white adjustment layer. Just click the icon that's shown on the photo, and then change opacity to 35 and Blend Mode to Soft Light.
5. Adjust contrast to -10.

http://llandscapes-ee1.kxcdn.com/wp-content/uploads/2015/04/91.jpg

6. Now, adjust vibrance and saturation. Set +10 for Vibrance and -10 for Saturation.

http://llandscapes-ee1.kxcdn.com/wp-content/uploads/2015/04/121.jpg

7. Then, adjust Exposure Adjustment. Set 0+40 for exposure, and +0.0500 for offset levels to lighten the photo.

http://llandscapes-ee1.kxcdn.com/wp-content/uploads/2015/04/141.jpg

8. That's it! After following the instructions, you'd get an end result like the one shown below.

http://llandscapes-ee1.kxcdn.com/wp-content/uploads/2015/04/23.jpg

Vintage Black and White Effect

There's Black and White. And then, there's Vintage Black and White.

Vintage Black and White Effects gives your photos more depth and give them that old-time feel. Think cinematic masterpieces of Old Hollywood and the like. It also works best for those purely black and white accounts, too.

Take a look at the sample original photo below:

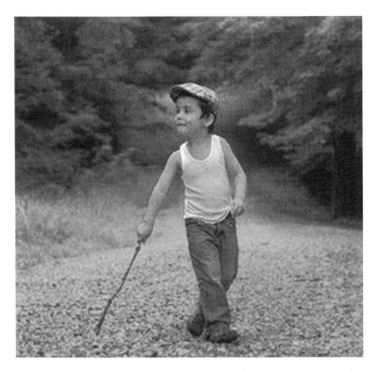

http://shutterpulse.com/wp-content/uploads/2014/12/16.jpg

1. The first thing you have to do is add a gradient map layer so you could properly convert colors into black and white. Set opacity to 100% and leave Blend Mode to Normal.

http://shutterpulse.com/wp-content/uploads/2014/12/35.jpg

2. Then, tweak adjustment layer and create a curve like the one shown on the photo below

http://shutterpulse.com/wp-content/uploads/2014/12/45.jpg

3. After doing so, go ahead and add another curve layer and lift the curve's middle area so that mid-tones would be lightened.

4. Set 0.90 as the mid-tone input, and set 245 as highlight output.

5. Next, adjust brightness and contrast. Set contrast to -35, and brightness to +15.

6 That's it—you now have a photo with this classic vintage feel!

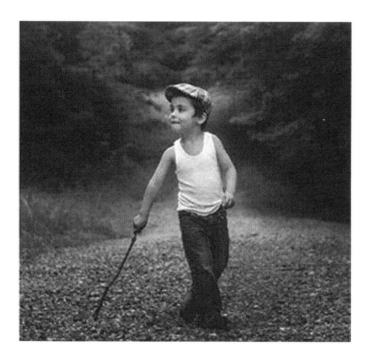

http://shutterpulse.com/wp-content/uploads/2014/12/26.jpg

Faded Cross Process Effect

You could also try making a Faded Cross Process Effect on your photos to give them this warm, vintage feel, without being too harsh on the eyes. This will let you work on three different adjustment layers, too.

Here's the original photo:

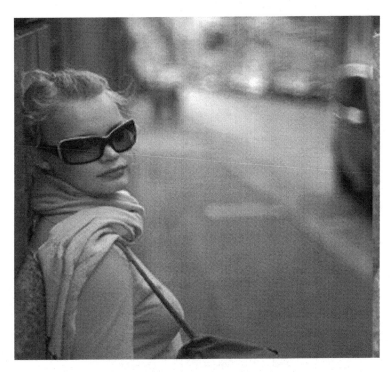

http://www.presetkingdom.com/wp-content/uploads/2015/06/24.jpg

To do the Faded Cross Process Effect, you should follow the instructions below:

1. Click the Adjustment layer and then add Curves Adjustment Layer.

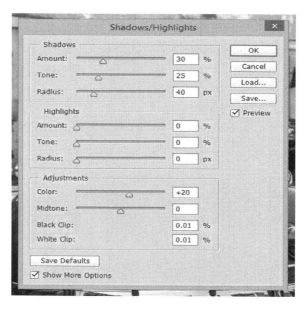

http://www.presetkingdom.com/wp-content/uploads/2015/06/33.jpg

2. Now, what will happen is that the dark areas of your photo would be lightened, and the next thing you have to do is tweak the red and green S curves, as shown on the photos below.

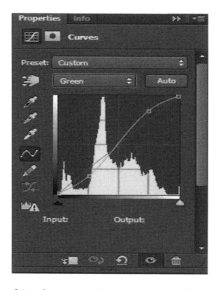

http://www.presetkingdom.com/wp-content/uploads/2015/06/53.jpg

3. Next, move on to the Blue Channel and create a Reverse S Curve.

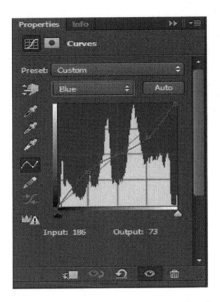

http://www.presetkingdom.com/wp-content/uploads/2015/06/63.jpg

4. Now, tweak your adjustment levels by setting 1.110 as mid-tone input, and setting 20 as the shadow.

5. Next, adjust brightness and contrast by setting Contrast to 25.

6. That's it—you'd now have a finished photo that looks like the one below.

http://www.presetkingdom.com/wp-content/uploads/2015/06/24.jpg\

Matte Effect

Why not create a Matte Effect on your photos?

With Matte Effects, your photos would have more warmth, and would definitely make them look more appealing—you'd probably want to frame them after!

Look at the original photo below:

http://ppimgs.s3.amazonaws.com/simple-matte-tut-2.jpg

To make it Matte and muted, you should:

1. Begin by opening the Adjustment layer and selecting Curves.
2. Create a curve like the one shown below, so mid-tones could be adjusted and darkened. This will be the base of your Matte effect.

http://ppimgs.s3.amazonaws.com/simple-matte-tut-5.jpg

3. Open the hue/saturation adjustment layer and then change saturation to -20 to soften the image.

http://ppimgs.s3.amazonaws.com/simple-matte-tut-7.jpg

4. Lastly, open the photo filter adjustment layer, and choose Photo Filter. After doing so, change Warming Filter to 85, and select 15% as the Density.

5.

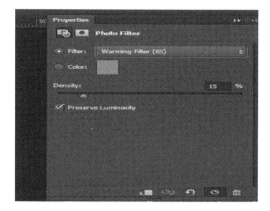

http://ppimgs.s3.amazonaws.com/simple-matte-tut-8.jpg

6. Voila! You'd now get a photo with matte effects, as shown below!

http://ppimgs.s3.amazonaws.com/simple-matte-tut-1.jpg

Realistic Makeup Application

Finally, learn how to edit photos on Instagram to give them a full glam, makeup look! This one is the simplest tutorial you can find—and it's also pretty effective.

Look at the Before and After photos for better understanding.

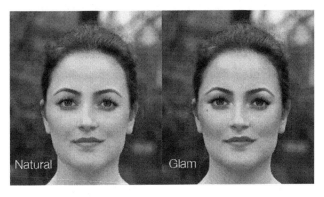

https://cdn.tutsplus.com/psd/uploads/legacy/0734_Retouch/final.jpg

1. You have to start by duplicating the original layer of the photo and then liquefying it. Just go to Filter>Liquefy.

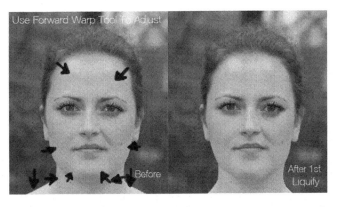

https://cdn.tutsplus.com/psd/uploads/legacy/0734_Retouch/2.jpg

2. Next, continue using the Liquefy option by means of raising eyebrows, corners of mouth, eye corners, and also by straightening the nose.

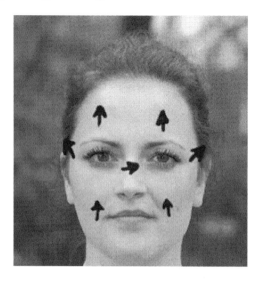

https://cdn.tutsplus.com/psd/uploads/legacy/0734_Retouch/3.jpg

3. Use the Forward Warp Tool to give the lips a more natural shape. You can also use the Bloat tool, but then again, you have to be careful because it might cause an unnatural bulge to the lips.

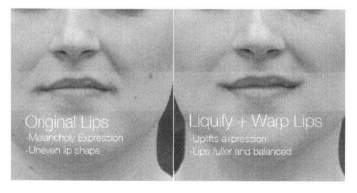

https://cdn.tutsplus.com/psd/uploads/legacy/0734_Retouch/4.jpg

4. Then, make use of the Clone Stamp Tool to lessen wrinkles, lighten dark circles, and erase spots. Basically, it's like using liquid foundation in real life.

5. Next, work on the eyebrows by using the Stamp Tool. Use it to create the base by stamping along the eyebrows, and using the brush tool for finishing the effect. Use Alt key to collect the brow color and then lessen opacity. Use Lasso to select which brow is better, and then use Eraser Tool to clean up.

6. Choose Edit, followed by Transform Horizontal, and then Flip Horizontal to bring the face back in position. Use Stamp Tool to correct discrepancies again.

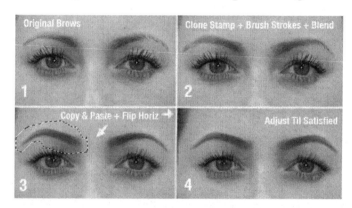

https://cdn.tutsplus.com/psd/uploads/legacy/0734_Retouch/6.jpg

7. Use Eyedropper and Brush Tools for contouring. Set Soft Light for the Brush Glow, and then select low opacity just near the cheekbone. Use Burn Tool for darkening surfaces.

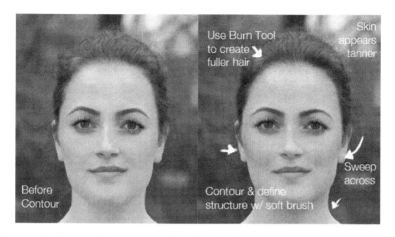

https://cdn.tutsplus.com/psd/uploads/legacy/0734_Retouch/8.jpg

8. Use Round Brush to define the lips by selecting the color of the top lip, and filling it with low opacity for perfect balance. Repeat process with the bottom lip, too.

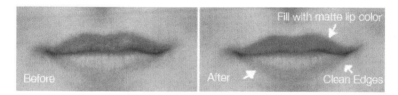

https://cdn.tutsplus.com/psd/uploads/legacy/0734_Retouch/10.jpg

9. Finally, improve clarity by adding another Curve Adjustment Layer. Bring the curve down, and then add another adjustment layer. Then, intensify the photo by means of adding another adjustment layer, and tweaking color balance. This would then make the look more natural.

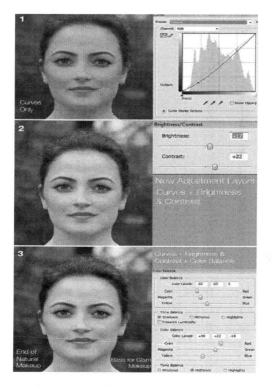

https://cdn.tutsplus.com/psd/uploads/legacy/0734_Retouch/11.jpg

10. That's it! You've now managed to put on some glam makeup on your subject!

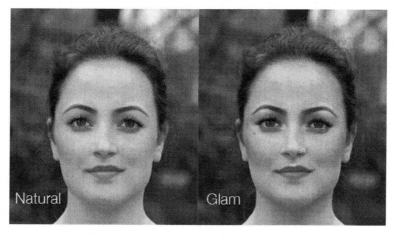

https://cdn.tutsplus.com/psd/uploads/legacy/0734_Retouch/final.jpg

Chapter 13: What to Avoid

Of course, as a beginner in the art of Photography, you can expect that there will be times when you'd make mistakes. It's a no-brainer.

But then again, you should also keep in mind that there are ways for these mistakes to be avoided—and you can find them all right here!

Not knowing how to use ISO

Using the ISO properly is one of the basic things that are taught to aspiring photographers. Heck, it was even discussed in the first chapter of this book.

When you use extremely high ISOs, what happens is that your photos turn to have extreme bursts of light in them. In short, your photos would be "noisy"—which isn't really a good thing.

To avoid this, just make sure that you set ISO into low levels, and make sure that aperture is wide. You can always rely on this trick to give you better photographs.

Focusing on wrong part of the Composition

Again, this has a lot to do with knowing what your visual focal point is.

For example, you're taking a photo of a debutante with her friends surrounding her. Would you actually focus on those other people, or would you focus on the debutante? Of course, the debutante should be the answer.

For this, you have to use the rule of thirds. Make sure your debutante is in the middle of the frame, and that you have angled your camera in such a way that the focal point is in the middle.

Interestingly, some cameras actually have a focus-lock option—make use of this to assure yourself that you're taking photos of the right focal point, instead of focusing on the clutter in the background. Using this button would also let your photos look more creative and appealing, too!

Not getting close enough to the subject

Aside from filling up the frame, you do have to make sure that you actually move close to your subject. Remember that you're the photographer here—so you have to take control of the situation.

Just walk closer to the subject, and then start filling your frame, just as you were taught earlier. Zooming in could also help you out—make use of that.

Not holding the camera straight

Sometimes, you end up with crooked photos because you didn't hold your camera straight—and that's never really a good thing.

What you have to do is check the viewfinder and use grids—it also has a lot to do with Rule of Thirds. Doing so would make it easier to edit the photos during post-processing, and you also avoid getting important elements cut off the screen.

Red Eyes

There are also times when your subjects end up with red eyes, which make them look like they're straight out of a horror movie. Is that appealing? Of course not.

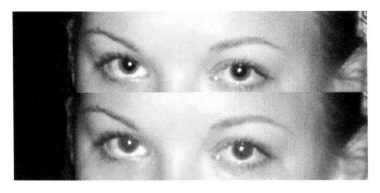

https://c2.staticflickr.com/4/3124/2307533035_08a41929bd.jpg

In order to prevent Red Eye from happening, you should try to do the following:

> Open curtains or turn lights on, instead of using a flash. This way, light would look more natural, and there won't be any unnecessary effects.

> When you ask your subject to look towards you, make sure that he doesn't look directly at the camera, and that he also doesn't look at the reflectors—or any source of bright lights.

> Check if your camera has in-eye red removal option, and make use of it.

Blowing Highlights

One of the worst things that you can do is blow highlights, or taking photos with practically white spots—like orbs, that could take focus away from your subject.

What you can do is practice shooting first, and then look at the camera's Histogram—also called Blinkies. Take a look if your camera has a blinking overlay option, and if it has, use it to cover blown-out areas in the photo.

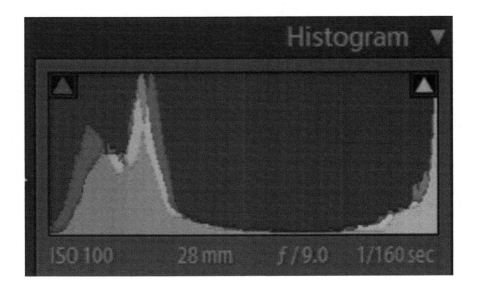

https://www.slrlounge.com/wp-content/uploads/2013/03/04-hdr-photography-correct-median-exposure-histogram.png

Never forget to check Histogram, especially after taking an important shot, and then try to shoot using lower exposures to create the perfect photo.

Blurry Photos

Photos turn out to be blurred mostly because of the settings you have used. In order to prevent this problem from happening, make sure that:

> You don't take too much time between pushing the trigger and eventually taking the picture. This period of time is called Shutter Lag, and you have to avoid it as much as possible.
>
> Try not to have shaky hands when using the camera. Just use a tripod, if necessary.

Try Action Shooting Mode for sports events, or times when the subject is moving. You could also try adjusting shutter speed manually—make it a bit faster.

Using Conflicting Elements

Say, you're trying to take a photo of some roses. And then, you've noticed that there's a spider, too, and yet, you still chose to take the photo.

It's not really nice, you know? This is because your audience would have no idea where they should focus on, and there's also the fact that spiders and roses don't really belong together.

Again, it all comes back to asking yourself what the purpose of the photo is, and what kind of story you want to tell. By doing so, you get to avoid making use of conflicting elements in your photo.

Not caring about the direction of the light

You've heard it a lot of times: *"Oh that photo is against the light"*, or *"Oh look, the photo's overexposed"*.

http://labirdiephotography.files.wordpress.com/2013/06/photo-1.jpg

Well, you can actually avoid this in the first place! For example, when something is casting unnecessary shadows over your subject, then make sure that that source of shadows is gone. Or, you can ask your subject to move in a different direction, too.

When using Artificial Light Sources, make sure you don't put them directly near your subject, so that the photos won't be overexposed.

It has a lot to do with trial and error, too. Take practice shots first, before finalizing everything. Don't put out a photo with not enough or too much light on it as it won't do anything good for your career.

Chapter 14: Other Things to Keep in Mind

What is it that you should actually keep in mind when it comes to taking photos? Well, there actually are a number of things, but more often than that, you have to make sure that you ask yourself some questions that will be able to help you determine what you're doing, and what it is that you have to do even more.

What are these questions then? Read on and find out.

What is it that I am trying to say? What story does this photo convey?

It all starts with these.

If you're trying to take professional photographs, you have to keep in mind that you shouldn't just take photos right away. In short, there has to be a purpose.

Remember when it was said earlier that you have to have an adjective in mind before taking a photo? Well, you have to take that rule when taking general photos, too.

Just ask yourself why you're trying to take that shot. Ask yourself what the photo would mean not only to you, but also to those who would see it. Is it just about capturing the moment? Or, do you want to make a story out of it?

By asking yourself these questions, you're able to come up with how to treat exposure, framing, composition, and all those other settings.

Think about your subject, and what's in the background. Think about various themes, such as:

Stylistic. This pertains to the repetition of styles and patterns used, like taking pictures of various flowers, and the like.

Visual. Of course, this has a lot to do with what people see—and how you want your photos to be perceived by others.

Relational. This has something to do with the people you're trying to take photos of. Who are they? What are they doing? What have they got to do with one another? Why are you taking their pictures?

Locational. These are photos taken in a certain location, and how the "story" progresses.

Also, take note of how you'd want to end your "Story". Take note that every photo has a story. Work on it, and try to see how others will perceive it to be.

Have you been using the Rule of Thirds?

The Rule of Thirds pertains to how a photo is cut into a grid, with nine squares. In the middle of the grid lay four grid markers—those are your Rule of Thirds.

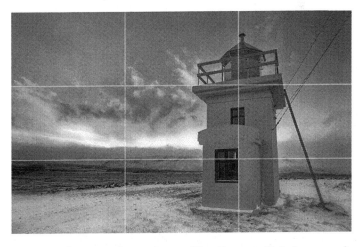

http://www.photographymad.com/files/images/lighthouse-rule-of-thirds.jpg

Basically, what you have to do is make sure that your subject is at least in the middle of those markers. This way, visual focal point—or the focus of the photo—will be on them. This works best for portrait photographs, amongst others.

To enhance focal point, you have to keep the following in mind:

Focus. Use Depth of Field settings to know where your focus is, and to blur other elements in the photo that aren't the visual focal point.

Position. Rule of thirds has a lot to do with this. Just refer to the paragraph above for details.

Shape. Make use of contrasting shapes and sizes to give your photos some texture and make them look more appealing.

Color. Use contrasting colors. These are colors on the opposing sides of the color wheel.

Size. Make sure that your focal point is larger than other elements in the photo.

Blur. Use slower shutter speeds to blur out other elements in the background.

Have you removed clutter from your photos?

Clutter means that there are other elements that take focus away from your visual focal point. This means that you have to make sure that they would no longer be around—and focus would be on your subject.

Here are some ways for you to take clutter away from your photos:

Change lenses or zoom to create various focal lengths. This way, you could crop any unwanted elements onscreen.

Be aware of highlights or contrasting colors that may be too strong—and could take focus away from your visual focal point.

Use the camera's viewfinder to check out a scene and see if it works for the idea that you have in mind. Take note that you can use alternative framing to produce better photos—so don't neglect that.

Composition: Fill the Frame

http://2.bp.blogspot.com/-d2j9YIY-
Fp4/U5horPh1IHI/AAAAAAAADW4/x6swwTH-pxs/s1600/umbrella-fill-
the-frame.jpg

Check foreground and background to look for anything distracting—and then use your hands to take those things away from the scene.

Try the de-cluttering effect after converting your photos to Sepia or Black and White. This way, the mix of colors would be perfect—and not too overwhelming.

Try using silhouettes to make the photos simple, but definitely more appealing.

Blur objects by using Depth of Field.

And, try to move your subject if necessary. This works best on portrait photographs.

Have you filled up your frame?

You also have to know whether you have maximized the use of your frame, or if your photos actually turn out to be a bit cluttered. You know, when people actually squint just to see what your photos are about.

Sometimes, it has a lot to do with not being able to make use of the space you have. Here are some ways for you to easily fill up your frame:

> **Never forget to use your legs**. Don't rely on the tripod alone. Try to move as necessary to capture the right photos, in the best angles.

> **Use Optical Zoom**. DSLRs have to be fitted with Optical Zoom, but Point and Shoot cameras already have them. They're there for a reason, so make sure that you use them.

> **Cropping is Okay.** By cropping your shots, you'll be able to create photos with the kind of focal point you want—and you'll be able to maximize the frame, too!

What about lighting? Do you have to use Artificial Light Sources?

Here's the thing: You really couldn't expect that all your photos will be taken outdoors. There are times when you have to do shoots at the studio, and of course, you won't have sunlight to help you in there.

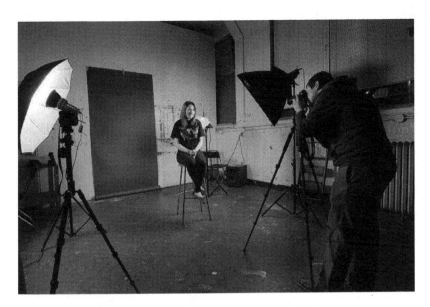

Times like this might lead to your subjects being overexposed, and could also cast harsh shadows behind them. In these cases, you need to make use of Artificial Light Sources, such as:

Flash Diffusers. By using flash diffusers, you're able to control flash, and bounce flash techniques so that light will be softened. There are various shapes and sizes of these, but most photographers say that it's best to go for built-in External Flash Units, like the one from *Canon*.

Flash Reflectors. Flash Reflectors are perfect from bouncing flash from one object to the other, while making sure that photos don't turn out to be against the light. Choose those reflectors that are white, and non-tinted, amongst others.

Umbrella Reflectors. These basically fire flash in wide settings, to make sure that light is balanced through and through.

Can I take this photo from another perspective?

And finally, another way of making sure that your photos turn out to be what you want them to be is by shooting from another perspective. You don't really have to just stand up all the time, you know?

Shooting from other perspectives include:

Climbing above a rock or a stool.

Crouching or lying in front of your subject.

And, shooting while the camera is on the ground.

http://mixbookblog.wpengine.netdna-cdn.com/wp-content/uploads/2012/08/Eiffel-Tower.jpg

You see, by asking yourself these questions, you're able to help yourself take the perfect photo—and that's something that you really would want to happen!

The Exposure Triangle

The Exposure Triangle is considered as the three most important elements of your camera, or of shooting. These elements are:

1. **Aperture**. This stands for how wide the lens of the camera gets when you take a picture.
2. **ISO.** ISO depicts the light sensitivity of the camera sensors.
3. **Shutter Speed.** And finally, there's shutter speed. Basically, shutter speed is about how much time has passed since the shutter has been opened.

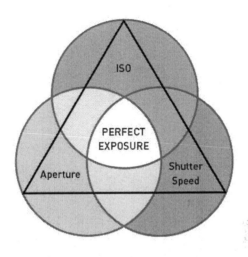

http://peaceofmyheartphoto.com/wp-content/uploads/2014/03/ExposureTriangle._V391966108_-1.jpg

How your picture would turn out would then depend on the Exposure Triangle elements. You can think of your camera as a window. You know how the shutters of a window could open and close, right? Well, that's how it goes for the shutters of your camera, too.

Now, Aperture stands for the size of the said window. Once aperture is wider, more light gets in, just like what happens when your windows are open wide. And then of course, the

amount of time that the windows are open all related to shutter speed.

When you're inside a room and you wear shades—or anything that could cover your eyes, light gets dim. And when you don't have anything to cover your eyes with, you tend to feel like the light is too bright—this is how you would define ISO. Basically, it's all about adjusting it to give you the best kind of picture you can take.

Tips to make the Exposure Triangle Work for You

ISO

For ISO, there are a couple of questions you have to ask yourself. Some of which are:

1. Do you want a grainy shot, or you want something that's really clear, and smooth?
2. How well-lit is the subject?
3. Is your subject stationary, or is it moving?
4. Would you have to use a tripod?

Aside from those, you have to keep in mind that you have to heighten ISO on certain occasions, such as:

1. No-flash, low-light zones, such as concerts.
2. Indoor Sports Events
3. Birthday Parties—especially those conducted under dim light
4. Churches, Art Galleries, etc.

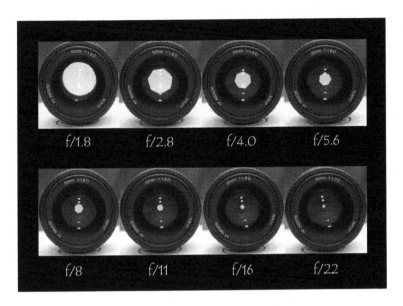

http://www.schoolofphotography.co.ke/wp-content/uploads/2015/10/Versatile-School-of-Photography-Aperture-f-stops.jpg

Aperture

Next, you have Aperture.

This isn't very hard because all you have to keep in mind is that the shallower it is, the more you'd get to focus on just a certain part of the photo, rather than the whole photo itself. This means you'd have to go for apertures like f/8, f/5.6, or f/4. Whereas you could use f/2 or f/1.4 for wider apertures—as in class pictures, group photos, etc. The key is to experiment to find the right aperture for you.

Shutter Speed

As for Shutter Speed, here's what you need to know:

1/60 is the recommended shutter speed. Doing so would prevent camera shake problems from happening.

Use tripod if shutter speed is other than 1/60. This is to make sure that again, your pictures won't come out to be shaky, and just to stabilize the whole shooting mechanism. However, if your camera has pre-set options for extremely slow shutter speeds, remember that it's okay to make use of this, too.

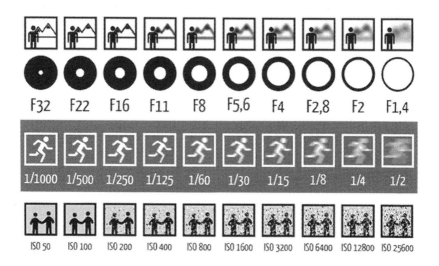

http://i.kinja-img.com/gawker-media/image/upload/iziot8egcqib3ylchmga.jpg

Doubling is okay. This means you'd have to double the shutter speed that you're going to use. It's okay because it adds more light to the photo, and would promote easy editing later.

Choose faster speeds for freezing. In taking jump shots, or photos of flying birds, make sure to choose faster shutter speeds.

Conclusion

Hopefully, you have learned the basics of photography after reading this book. Now, all you need to do is to apply what you have just read and understood. Don't be afraid to experiment with different settings and combinations — doing so will allow you to tap into your inner photographer and you will discover that you are more creative than you initially thought.

Now, it's time for you to up the ante in your knowledge about photography. The next topic that you need to learn is photo composition.

Finally, if you enjoyed this book, please take the time to share your thoughts and post a positive review on Amazon. It'd be greatly appreciated!

Thank you and good luck!

62853605R00088